THE *Budget-Savvy* WEDDING PLANNER & ORGANIZER

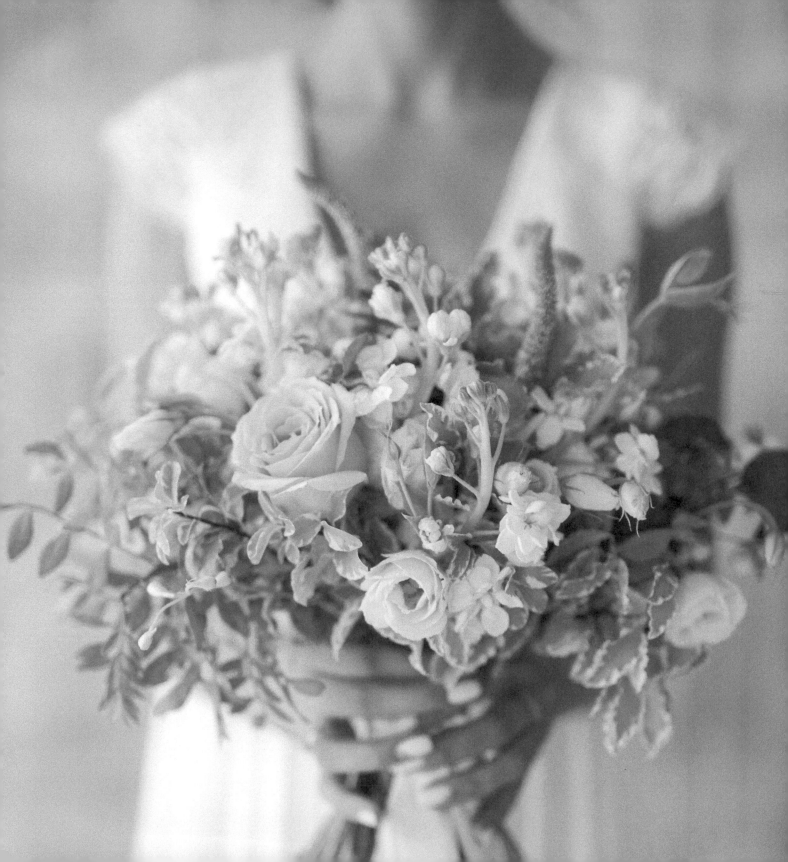

THE
Budget-Savvy
WEDDING PLANNER & ORGANIZER

Checklists, Worksheets, and Essential Tools
to Plan the Perfect Wedding on a Small Budget

JESSICA BISHOP

TEMESCAL
PRESS

For general information on our other products and services or to obtain technical support, please contact our Customer Care Department within the U.S. at (866) 744-2665, or outside the U.S. at (510) 253-0500.

Temescal Press publishes its books in a variety of electronic and print formats. Some content that appears in print may not be available in electronic books, and vice versa.

TRADEMARKS: Temescal Press and the Temescal Press logo are trademarks or registered trademarks of Callisto Media Inc. and/or its affiliates, in the United States and other countries, and may not be used without written permission. All other trademarks are the property of their respective owners. Temescal Press is not associated with any product or vendor mentioned in this book.

Photography © Milles Studio/Stocksy, p. ii; Seth Mourra/Stocksy, p. vi; Ani Dimi/Stocksy, p. x; Thomas Pickard/Stocksy, p. 16; IVASHstudio/Shutterstock.com, p. 34; @e.cook46 via Twenty20, p. 46; Wendy Laurel/Stocksy, p. 62; Shawn Roller, p. 72; @NickBulanovv via Twenty20, p. 94; Sidney Morgan/Stocksy, p. 102; Annie Spratt via Unsplash, p. 126; @isamorales via Twenty20, p. 148; Neustockimages/iStock.com, p. 156; @ryandread via Twenty20, p. 166; Visualspectrum/Stocksy, p. 178; Budrio/iStock, p. 186.

Illustrations by Alyssa Nassner

ISBN: Print 978-1-62315-985-6 | eBook 978-1-62315-986-3

Printed in Canada

To my family:
Thank you for loving and supporting me
through all of my crazy ideas, changes in direction,
and leaps of faith.

CONTENTS

Introduction viii

1 The Vision 1

2 The Budget 17

3 The Guest List 35

4 The Venue 47

5 The Invites 63

6 Your Wedding-Day Look 73

7 The Wedding Party 95

8 Photography, Music, Food, Cake, and More 103

9 Decor, Rentals, Flowers, and Favors 127

10 The Other Parties 147

11 Accommodations, Transportation, and More 155

12 The Big Day 165

13 On to the Honeymoon 177

Contract & Negotiation Tips 185

Important Names & Numbers 187

Resources 191

Index 193

INTRODUCTION

CONGRATULATIONS! If you're reading this book, you've likely already achieved one of the greatest feats in life: finding someone you want to spend the rest of your life with. As if that weren't already a huge accomplishment, now the two of you are tasked with throwing a party to celebrate your official union—otherwise known as planning a wedding.

I hope you've taken a few weeks—or at least a few moments—to bask in your newly engaged love bubble before diving headfirst down the rabbit hole of wedding planning. If you've done any amount of initial research, you may feel overwhelmed, nervous, or downright terrified at the potential cost of a wedding. It's no surprise that you'd feel that way, considering media-reported figures of wedding costs in the United States continue to climb year over year. When the "average" American wedding supposedly runs upward of $30,000, it's understandable that you might be second-guessing a traditional celebration.

But here's the secret: You don't need to spend the equivalent of a starting salary on your wedding day for it to be memorable, impactful, or beautiful. In fact, you don't even have to spend half that.

If you've read other wedding-planning books or resources, you may have noticed that most of the advice and information they contain is directed toward couples who are spending many pretty pennies on their big day. If it makes you squeamish to think about blowing your or your families' hard-earned dollars on what is essentially a big, fancy party, then this planner is for you. This planner is for couples who are working with limited funds to plan their big day, whether due to personal finances or personal choice.

For me? It was a combination of both. My fiancé and I couldn't fathom or justify spending so much money on a one-day event. We had other priorities, including purchasing our first home, traveling, and building our savings. We knew we didn't want to spend more than $10,000 on our wedding and made it our mission to stick to that budget.

Between planning my own budget-savvy wedding and running my website, *The Budget Savvy Bride,* for the last 10 years, I've picked up some incredible savings tactics, tips, and tricks that I am so excited to share with you in this book. Since starting the blog, I've featured hundreds of real weddings planned by couples on budgets of less than $20,000. It *is* possible to have a beautiful wedding on a budget you can afford, and using this book is going to help you do just that.

Whether your wedding budget is $1,500 or $15,000, this planner will help you stay organized and on track while you plan your big day. Not only will I be sharing my biggest money-saving tips and tricks, but you'll also have plenty of space to make notes, brainstorm, and record your plans along the way. This book's about to become your budget-savvy BFF!

xo, Jessica

The Vision

PLANNING A WEDDING IS quite an undertaking, and it's even more challenging for couples who are on a tight budget. But just like any other large project, it's important to focus on the big picture. Take time to home in on your vision for your wedding as well as establish your goals and priorities. The exercises and worksheets in this chapter will help you do just that. Once you've established this baseline, you can follow our detailed checklists for getting it all done.

What's the first step? Take a little time to dream. Yep, my expert advice is to daydream with your beloved about the type of life you want together. Taking the time to consider these important subjects will help you plan your wedding in a way that aligns with your core values and life goals. When you know where your priorities lie and commit to sticking to your values, you will find it easier to stick to your budget, as well.

Focus on the overall vision for your wedding. Tackle the big ideas first: size, setting, style, vibe, and timeline. These five points will be the biggest determining factors of your wedding budget and will give you an overall framework to build upon.

SAVVY TIPS

I. CONSIDER YOUR MOTIVATION. Have you ever stopped to ask yourself exactly why you want to have a wedding? Now's a good time to do that. Is it because you want to wear the fancy clothes or have a really awesome party? Or is it more about celebrating with your nearest and dearest? What values align with your motivation? This should inform your thinking from the start of planning your big day.

2. REMEMBER YOUR VALUES. After you've identified your values and motivations, make sure your decisions reflect them. Write them down and keep them handy so you can reference them throughout the planning process.

3. STAY TRUE TO YOU. Take unsolicited advice and others' opinions with a grain of salt. Remember, this is your day. You want it to be a true reflection of both of you, so feel free to block out the noise if necessary.

4. RANK YOUR PRIORITIES AND COMPARE. Both you and your partner should consider the typical wedding line items and choose your top two or three priorities. Compare your picks and see if there are overlaps or if you'll need to compromise.

5. MAKE IT FUN. You two crazy kids are in love and you're planning this wedding to celebrate that love, right? Don't let wedding planning feel like a chore. Find ways to make it fun.

DISCUSSION QUESTIONS

It's time to figure out what really matters to you so you can plan a wedding that fits the two of you perfectly. To get the process started, ask yourselves the following questions.

I. Why does having a wedding matter to us?

2. What is our ultimate goal with planning a wedding?

3. How do we want to feel on our wedding day? Relaxed, energized, elated?

4. Do we see our ideal wedding as a big, raucous party with everyone we know or an intimate affair with close friends and family only?

5. How would we describe our personalities or overall vibes? Are we cosmopolitan chic or laid-back casual?

6. Is tradition important to us or either of our families? Or do we want to go our own way?

7. Are there certain elements of the wedding that are of high priority to us? What are we not willing to sacrifice? (We'll dive deeper into this later, in Identify Your Priorities on page 4.)

8. What are our biggest financial priorities in the next five years? Are we planning to buy a house, have a child, or make any other big financial decisions?

YOUR VISION WORKSHEET

Use this worksheet to determine your wedding preferences, including season, size, style, and setting. The results will serve as your wedding framework to guide your decisions as you work through the rest of the planning process. Circle the option(s) that best suit your style.

SIZE

Large Party · (Midsize Bash) · Small Gathering

SETTING

Indoor · Outdoor · (Both)

SEASON

Winter · Spring · Summer · (Fall)

IDEAL VENUE

Art Gallery	Event Venue	Museum
Backyard	Farm	Park
Ballroom	Garden	Plantation
Barn	Golf Course	Private Residence
Beach	Greenhouse	Ranch
Bed and Breakfast	Historical Venue	Resort
Boat	Hotel	Restaurant
Brewery	Inn	Rooftop
Castle	Island	Tent
Church	Lakeside	Villa
City Hall	Library	Vineyard
Country Club	Lodge	Warehouse
Desert	Loft	Woodland
Estate	Mansion	Yacht Club
	Mountain	Zoo

PERSONAL STYLE

Bohemian	Fantasy	Organic
Budget	Feminine	Preppy
Casual	Glamorous	Religious
Classic	Holiday	Retro
Coastal	Indie	Rock and Roll
Cultural	Industrial	Romantic
Destination	Military	Rustic
DIY	Minimalist	Tropical
Eclectic	Modern	Vintage
Eco-friendly	Nautical	Whimsical
Elegant	Offbeat	

FILL IN THE BLANKS

Where You Live Now: Allenstown, NH

Partner 1's Hometown: Weare, NH

Partner 2's Hometown: Weare, NH

Where You Met: Weare, NH 101

Another Place of Significance in Your Relationship: UNH

IDENTIFY YOUR PRIORITIES

This page contains a list of all the typical elements involved in a traditional wedding. Many of these won't apply or be included in your wedding-day plans.

When you're working with a limited budget, it's likely that you'll have to make sacrifices, but that doesn't mean your wedding can't still be awesome! Instead of looking at this list from a negative standpoint, look at it from a place of power. This is your opportunity to weed out all the things you're not interested in including in your day. Feel free to attack this list with a red pen, crossing out all the items you are saying *no* to. Circle the items that are important to include, and star the ones you're most excited about.

COUPLE

BRIDE

Wedding Dress	Shoes	Makeup and Hair
Accessories and Jewelry	Veil or Headpiece	Wedding Ring

GROOM

Wedding Suit or Tuxedo	Shoes	Watch
Cuff Links	Socks	Wedding Ring
	Lapel Pin	

WEDDING PARTY

BRIDESMAIDS

Bridesmaid Dresses	Jewelry	Gifts
	Shoes	

GROOMSMEN

Suits or Tuxedos	Shoes	Gifts
Ties	Socks	

FLOWER GIRL

Flower Girl Dress	Flower Girl Jewelry	Flower Girl Basket	Flower Girl Gift

RING BEARER

Ring Bearer Outfit	Ring Pillow or Box	Ring Bearer Gift

GUESTBOOK ATTENDANT

Attire	Gifts

USHERS

Attire	Gifts

CEREMONY

TRADITIONS

Standard Vows

Self-Written Vows

Special Readings

MUSIC

Playlist

Special Songs

Live Musicians

MISCELLANEOUS

Marriage License

Officiant

Guest Book

Programs

FLORALS

Altar Arrangements

Bridesmaid Bouquets

Family Boutonnieres

Bridal Bouquet

Boutonnieres

Miscellaneous Florals

Family Corsages

RECEPTION

BEVERAGES

Cocktail Hour

Beer and Wine

Champagne Toast

Open Bar

Nonalcoholic Beverages

RENTAL EQUIPMENT

Lighting

Dance Floor

Rental Decor

Tent

Lounge Furniture

FOOD

Appetizers

Buffet-Style Meal

Desserts

Full-Service Meal

Late-Night Snacks

Wedding Cake

Groom's Cake

ENTERTAINMENT

Dance Party

Photo Booth

Karaoke

Games

FAVORS

DIY

Purchased

Plants

Edible

Charitable Donations

Personalized

TRADITIONS

Receiving Line

Dances with Parents

Toasts or Speeches

Wedding Party Intro

Garter Toss

Cake Cutting

Couple Intro

Bouquet Toss

Grand Exit

First Dance

TABLES AND SEATING

Dinner Tables

Place Cards

Monogrammed Napkins

Cocktail Tables

Seating Chart

Linens

Chairs

Flatware

Table Runners

Centerpieces

Disposable Cutlery

Candles

MUSIC

DJ

Live Band

Playlist

Continued

TRANSPORTATION

Limo Bus Getaway Car

PAPER GOODS

Save-the-Dates Calligraphy Thank-You Cards

Invitations Signage Printed Menus

LOGISTICS

TYPE OF WEDDING

Daytime Wedding Destination Wedding Secular Ceremony

Nighttime Wedding Indoor Wedding Large Guest List

Local Wedding Outdoor Wedding Small Guest List

Religious Ceremony

VENDORS AND SERVICES

Day-Of Coordinator Caterer Hair and Makeup Services

Photographer Baker Musicians

Videographer Florist

ACCOMMODATIONS

Night before the Wedding Wedding Night

PRE-/POST-WEDDING EVENTS

Rehearsal Dinner Day-After Brunch

Ways to Save

SLASH YOUR GUEST LIST. Cutting the guest list is the top tip for saving money on a wedding because it works. While you can absolutely have an extravagant wedding for a small group of people, it's important to note that your budget will go further with fewer guests.

CHOOSE AN AFFORDABLE DATE. Prices vary in different areas depending on the season, so choosing an off-peak date can yield significant savings. A general rule of thumb is that winter is considered off-peak, but check with the venues to see when their slow months are. You can save even more by selecting a day other than Saturday.

DIY, WITHIN REASON. You and your partner each have talents and skills, so put them to use for your wedding! Whether you plan to bake your own cupcakes or your partner designs your wedding website, you'll likely save money by doing some things yourselves. Be sure to not take on too much, but you will be amazed at what you can save if you tackle some to-dos yourselves.

LIMIT THE BAR. One of the biggest wedding expenditures tends to be the bar during the reception, so put a limit on booze. Opting for beer and wine over a full bar will save a good deal.

RECYCLE, REUSE, AND REPURPOSE. Take inventory of what you have in your own home and see how you could incorporate personal pieces into your big-day decor. Including elements from home will help your personal style shine through while saving you on decor rentals.

RECRUIT TALENTED FRIENDS. Those who can't do . . . ask their talented friends who can! Utilizing the skills of your family and friends in place of hiring professionals can save you big bucks.

USE FRESH FLOWERS SPARINGLY. Big blooming arrangements are beautiful, but they can also bust your budget! Give your wedding a lush look for less by incorporating greenery in lieu of loads of florals.

CHOOSE A NATURALLY BEAUTIFUL LOCATION. When your venue is naturally beautiful, you won't feel the need to splurge on unnecessary decor. Gardens and beaches are two options that don't need much in the way of decoration to look wedding-ready.

BEG, BORROW, AND THRIFT. Need jars for your candy buffet or a platter for your guest book table? Borrow them from family or friends instead of buying new. It's always a good idea to head to your local thrift store and score decor on the cheap!

BE YOUR OWN DJ. If you've got a speaker system to amplify your tunes, this is a pretty simple way to save yourself some cash. Just be sure to designate a friend to start and stop the music during key moments of the reception.

THE PERFECT CELEBRATION

After completing the worksheets on the previous pages, let's take a moment to refine the vision for your day. Using the space below, write down your key takeaways from these discussions to help build your wedding blueprint.

THE VISION

Our biggest priorities are:

1. ...

...

2. ...

...

3. ...

...

We want our wedding to take place in:

...

If our wedding had a personality, we'd describe it as:

...

...

OUR WEDDING AESTHETIC

We want our wedding to look like:

...

...

...

...

...

...

...

...

...

WEDDING VIBES

We want our wedding to feel like:

...

...

...

...

...

...

...

WEDDING GOALS

The ultimate goal for our wedding is:

...

...

...

...

...

...

...

ONE-YEAR TIMELINE

★ Consider DIY to save money

♥ Consider asking a talented friend or family member to help

10 TO 12 MONTHS OUT	NOTES	DATE COMPLETED
☐ Determine Vision		
☐ Calculate Budget		
☐ Set the Date		
☐ Create Guest List		
☐ Book Ceremony and Reception Venues		
☐ Decide What to DIY ★		
☐ Research and Book Photographer		
☐ Choose Officiant ♥		
☐ Select and Ask Bridal Party		
☐ Consider Hiring Day-Of Coordinator ♥		
☐ Set Color Scheme		
☐ Create Wedding Website ★		

8 TO 10 MONTHS OUT	NOTES	DATE COMPLETED
☐ Research, Taste, and Select Caterer		
☐ Find and Book Florist ♥ (if not DIYing ★)		
☐ Start Dress Search		
☐ Pick Bridesmaid Attire		
☐ Choose Groom and Groomsmen Attire		
☐ Research and Reserve Hotel Room Blocks		
☐ Schedule Cake Tastings and Choose Baker ♥		
☐ Hire DJ ♥ (optional ★)		
☐ Gather Decor Inspiration		
☐ Buy Supplies for DIY Projects (ongoing) ★		

6 TO 8 MONTHS OUT	NOTES	DATE COMPLETED
❏ Reserve Rental Items		
❏ Start DIY Projects ★		
❏ Create and Send Save-the-Dates ★		
❏ Buy Flower Girl and Ring Bearer Attire		
❏ Register for Gifts		
❏ Work with Caterer to Set Menu		
❏ Research and Book Honeymoon		

4 TO 6 MONTHS OUT	NOTES	DATE COMPLETED
❏ Select Music for Ceremony ★		
❏ Decide on Wedding-Day Transportation		
❏ Select Final Bouquet Styles		
❏ Choose Boutonnieres		
❏ Finalize Centerpiece Design		
❏ Order Flowers (with Florist ♥ or Wholesale Supplier to DIY ★)		
❏ Select Wedding-Day Accessories		
❏ Select and Purchase Wedding Bands		

3 TO 4 MONTHS OUT	NOTES	DATE COMPLETED
❏ Pick Reception Playlist ★ or Verify Playlist with DJ ♥		
❏ Choose and Order Wedding Invitations ♥ or DIY Wedding Invitations ★		
❏ Finalize Order of Ceremony, Readings, and Vows		
❏ Purchase or DIY Wedding Favors ★		
❏ Purchase or DIY Decor for Wedding ★		

2 MONTHS OUT	NOTES	DATE COMPLETED
❑ Purchase or DIY Bridal Party Gifts ★		
❑ Send Wedding Invitations		
❑ Write Thank-You Notes as Gifts Come In		
❑ Make Plans for Getting Ready Day-Of		
❑ Purchase or DIY Guest Book ★		
❑ Select Songs for First Dance and Dances with Parents		

MONTH OF THE WEDDING!	NOTES	DATE COMPLETED
❑ Have Final Suit and Dress Fittings		
❑ Get Marriage License		
❑ Work on Wedding-Day Timeline		
❑ Collect Outstanding RSVPs		
❑ Confirm Reception Toasts or Speeches		
❑ Give Final Headcounts to Caterer		
❑ Purchase Wine, Beer, or Liquor if BYOB		
❑ Gather Final Invoices from Vendors		
❑ Organize Decor and DIY Projects for Easy Transport		
❑ Pack Wedding Emergency Kit		
❑ Confirm Beauty Appointments		
❑ Print Menus and Programs ★		
❑ Finalize Seating Chart ★ (optional)		
❑ Hair and Makeup Trial		

WEEK OF THE WEDDING!	NOTES	DATE COMPLETED
❑ Pack Wedding-Night Bag		
❑ Get Dress Steamed		
❑ Assemble Welcome Bags ★		
❑ Finalize Wedding Day Timeline		
❑ Confirm Timing with All Vendors		

SIX-MONTH TIMELINE

★ Consider DIY to save money

♥ Consider asking a talented friend or family member to help

6 MONTHS OUT	NOTES	DATE COMPLETED
☐ Determine Vision		
☐ Calculate Budget		
☐ Set the Date		
☐ Create Guest List		
☐ Book Ceremony and Reception Venues		
☐ Decide What to DIY ★		
☐ Research and Book Photographer		
☐ Choose Officiant ♥		
☐ Select and Ask Bridal Party		
☐ Consider Hiring Day-Of Coordinator ♥		
☐ Set Color Scheme		
☐ Create Wedding Website ★		
☐ Research, Taste, and Select Caterer		
☐ Find and Book Florist ♥ (if not DIYing ★)		
☐ Start Dress Search		
☐ Pick Bridesmaid Attire		
☐ Choose Groom and Groomsmen Attire		
☐ Research and Reserve Hotel Room Blocks		
☐ Schedule Cake Tastings and Choose Baker ♥		
☐ Hire DJ ♥ (optional ★)		
☐ Gather Decor Inspiration		
☐ Buy Supplies for DIY Projects (ongoing) ★		
☐ Reserve Rental Items		

5 MONTHS OUT	NOTES	DATE COMPLETED
❏ Start DIY Projects ★		
❏ Create and Send Save-the-Dates ★		
❏ Buy Flower Girl and Ring Bearer Attire		
❏ Register for Gifts		
❏ Work with Caterer to Set Menu		
❏ Research and Book Honeymoon		
❏ Select Music for Ceremony ★		
❏ Decide on Wedding-Day Transportation		
❏ Select Final Bouquet Styles		
❏ Choose Boutonnieres		
❏ Finalize Centerpiece Design		
❏ Order Flowers (with Florist ♥ or Wholesale Supplier to DIY ★)		
❏ Select Wedding-Day Accessories		
❏ Select and Purchase Wedding Bands		

3 TO 4 MONTHS OUT	NOTES	DATE COMPLETED
❏ Pick Reception Playlist ★ or Verify Playlist with DJ ♥		
❏ Choose and Order Wedding Invitations ♥ or DIY Wedding Invitations ★		
❏ Finalize Order of Ceremony, Readings, and Vows		
❏ Purchase or DIY Wedding Favors ★		

2 MONTHS OUT	NOTES	DATE COMPLETED
❏ Purchase or DIY Bridal Party Gifts ★		
❏ Send Wedding Invitations		
❏ Make Plans for Getting Ready Day-Of		
❏ Purchase or DIY Guest Book ★		
❏ Select Songs for First Dance and Dances with Parents		

THE VISION

MONTH OF THE WEDDING!	NOTES	DATE COMPLETED
❏ Have Final Suit and Dress Fittings		
❏ Get Marriage License		
❏ Work on Wedding-Day Timeline		
❏ Collect Outstanding RSVPs		
❏ Write Thank-You Notes as Gifts Come In		
❏ Confirm Reception Toasts or Speeches		
❏ Give Final Headcounts to Caterer		
❏ Purchase Wine, Beer, or Liquor if BYOB		
❏ Gather Final Invoices from Vendors		
❏ Organize Decor and DIY Projects for Easy Transport		
❏ Pack Wedding Emergency Kit		
❏ Confirm Beauty Appointments		
❏ Print Menus and Programs ★		
❏ Finalize Seating Chart ★ (optional)		
❏ Hair and Makeup Trial		

WEEK OF THE WEDDING!	NOTES	DATE COMPLETED
❏ Pack Wedding-Night Bag		
❏ Pack Honeymoon Suitcase		
❏ Get Dress Steamed		
❏ Assemble Welcome Bags ★		
❏ Finalize Wedding-Day Timeline		
❏ Confirm Timing with All Vendors		

Destination Weddings

Couples who love to travel and want their wedding day to be more of an experience might consider having a destination wedding. Surprisingly, even with travel costs, destination weddings can be pretty affordable. If you're on the fence, check out this list of pros and cons of having a destination wedding.

PROS

- Typically, fewer people are willing or able to travel, especially internationally. Having a destination wedding could potentially trim your guest list for you.

- You will have more time with your loved ones to create cherished memories and enjoy the experience together.

- Many resorts offer all-inclusive packages with wedding teams that take care of all the details. This option can be very tempting for no-fuss couples!

- You will already be in an amazing location, so you won't need to travel again for your honeymoon. Just extend your stay and bask in married bliss.

- Destination weddings just seem to have a more relaxed vibe. It's like a celebration of your love while on a fabulous vacation. What's not to like?

CONS

- People you love may not be able to make it. Not everyone has the funds or ability to travel, especially internationally.

- You'll be planning your wedding from a distance, which can make certain things more difficult.

- There might be extra paperwork and logistical details that you'll need to take care of to ensure that your ceremony is legal.

- Unless you have the availability and funds to visit a property before purchasing your wedding package, you'll be booking sight unseen. Take online reviews with a grain of salt, and realize that things may not be exactly as they appear in photos.

- Shipping and customs fees can add hassle and expense to your wedding if you're planning on sending decor or other wedding accessories via mail. Be prepared to pay any related fees, or bring them with you in your suitcases.

The Budget

NOW THAT YOU'VE OUTLINED your goals and priorities for your wedding, it's time to crunch the numbers. The amount you choose to spend on your wedding day is an incredibly personal choice, and several factors come into play when making that decision. From figuring out who's paying for what, to combining all the contributions, to tallying the total, this chapter will outline a simple process to help you calculate and allocate your wedding budget.

Use the worksheets in this section to record any money you'll be receiving from your families and when to expect it. You'll have space to factor in your and your partner's savings and determine how much to put toward the big day. You'll also learn the best way to create a monthly savings plan to build your wedding fund over the course of your engagement. As a bonus, you'll even discover some of the top tips for finding or earning extra money to finance your big-day goals.

Overall, this chapter is going to help you top to bottom when it comes to the currency of your wedding celebration. Let's get started!

SAVVY TIPS

1. DETERMINE YOUR OWN CONTRIBUTIONS. Chat with your future spouse to figure out how much you each can or plan to contribute to your wedding fund. Factor in your savings as well as any money you can save along the way to put toward wedding expenses. If your families don't offer you any money, this may be all you have to work with.

2. HAVE "THE TALK." Have a sit-down with each of your immediate families as well as any other parties who may be keen to contribute to the celebration. Ask your families if they plan to help pay for various aspects of the wedding, and if so, how much? Get total figures if possible. Remember, this isn't a guarantee or obligation, and you should be gracious no matter what they decide.

3. SET EXPECTATIONS. Once you know how much your families are planning to pitch in for the wedding, make sure you get clear on how the funds will be delivered and when to expect them. Will they be giving you a lump sum of cash or sending deposits on an ongoing basis? They could also choose to pay for certain services or vendors directly.

4. BE AWARE OF THE COST BEYOND THE FINANCIAL. Remember, accepting money from your families will provide them license to have more of a say in wedding plans. If you are a bit of a control freak, be sure to weigh the cost of accepting contributions with this in mind. Define the level of involvement any contributors are seeking in exchange for their funding.

5. TALLY UP THE TOTAL AND MAKE A PLAN. Combine all the monetary amounts from the various sources, and you have your wedding budget total. Open up a new joint bank account to house your wedding fund and set up a savings plan. Will you be putting the expenses on a points-earning credit card when possible, or will you be paying with cash or check? Make a game plan for how you'll handle payments for wedding expenses.

FIGURING OUT THE FINANCES

If getting through the wedding planning process without a heap of debt and regret is a priority for you, you'll want to get clear about how much you are able and willing to spend on this celebration. Check out the following advice to learn how to determine the right amounts for you and your partner.

Get Real about Your Savings

To figure out how much money you and your partner can each put toward your wedding, start by looking at both of your savings. It's always a good idea to have an emergency savings account in place in case of unexpected expenses, job loss, or other financial woes. A good rule of thumb is that you should have at least three months' worth of essential living

expenses in savings before you begin to prioritize other savings goals. If you don't yet have that financial cushion in place, filling your emergency fund should take priority over paying for a wedding.

If you're rocking a fully stocked emergency fund, take a look at your excess savings—anything over that three-month-essentials amount. How much of that extra cash are you willing to put toward your wedding? Make a decision you feel comfortable with, and add it to the worksheet on page 21.

Examine Your Monthly Budgets

It's helpful to have an idea of each of your monthly budgets so you can determine how much you can put toward your wedding fund during your engagement. A common approach for setting a personal budget is adhering to the 50/20/30 rule. This general guideline provides a formula for dividing your monthly income among your various monthly expenses.

You can basically break your monthly budget into three main categories: essential living expenses (fixed monthly costs, like rent, utilities, car payments, cable/Internet, membership fees, and insurance), financial goals (paying down debt, saving for emergencies, other savings goals), and personal expenses (flexible expenses that vary from month to month, such as groceries, dining, entertainment, travel, and shopping). Examine your personal spending and see if you're adhering

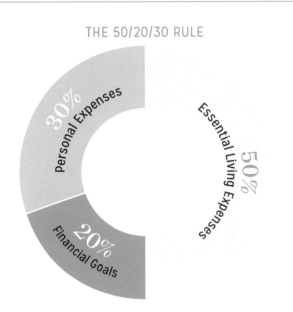

to these percentages. If not, you may want to rearrange some of your priorities to get yourself in alignment. You don't want to live like a hermit during your engagement, but you can potentially identify areas where you can save extra cash to contribute to the wedding fund.

Use a service like Mint (a website and phone app) to analyze your current spending habits and see where your money is going. Then, identify areas where you could be spending less than you are currently in order to free up funds to support your wedding plans. Perhaps you decide to cancel your cable and put that extra $100 per month toward the wedding fund. Or maybe you choose to show some shopping restraint during your engagement in favor of allocating your clothing

budget toward the big day. Some couples will decide to go ahead and move in together if they aren't already cohabitating in order to cut their living expenses. These are all personal choices and totally up to you!

Make a Monthly Savings Plan

After you've each looked at the breakdown of your income versus expenses and identified some areas where you can free up some of your cash, it's time to put a savings plan in place. Register for a banking service that allows for automatic withdrawals, such as Capital One 360. For example, this bank lets you schedule regular transfers of money from your checking to a dedicated savings account at intervals of your choosing. You can easily set up the withdrawals to occur at a biweekly or monthly pace, depending on your payment schedules. This way, your wedding fund gets filled automatically, without any extra effort on your part.

Budget Real Talk

Planning a wedding and sticking to a budget is not without sacrifice. You'll have to decide what is more important to you: having the wedding you want or having all the creature comforts you enjoy throughout the planning process.

Every person comes from a different set of circumstances, and it's possible that your family will not contribute to your wedding budget. Remember that their offerings are a gift, and you should be gracious no matter how much they contribute.

If you're planning to contribute to your wedding fund along the way, the length of your engagement will affect your budget's bottom line. The longer your engagement is, the longer you can save up, and the more money you'll have to work with. Keep this in mind if your vision is loftier than your wallet currently allows for.

If your families offer you money to help pay for the wedding, you may not have to be quite as aggressive in your saving strategies. But these tactics will come in handy, especially if there are particular items you'd like to splurge on!

Have a maximum budget in mind. Based on your own goals and personal values, is there a figure that you absolutely don't want to exceed? Even if that number is less than what you technically could afford to spend, it's a good idea to stick to your guns if you have a strong opinion.

COUPLE CONTRIBUTIONS WORKSHEET

Before you discuss monetary gifts with your parents and families, figure out how much you and your partner are able to contribute and save up for your plans. Not everyone's families are willing to foot the bill for a wedding, and you should never expect that yours will cover the whole cost or even some of it. Just in case you have to take matters completely into your own hands, here's a chart to help you figure out how much you can afford to spend.

Suggested Budget Percentages

	MONTHLY INCOME	50% LIVING ESSENTIALS	20% FINANCIAL GOALS	30% PERSONAL EXPENSES
Partner 1				
Partner 2				

Use this chart to list all your monthly expenses. When you're finished, place a star next to items that are negotiable or able to be changed. Keep a tally of all the savings you're creating by cutting back in these areas, and add that to your monthly wedding contribution.

FIXED EXPENSES	PARTNER 1	PARTNER 2
Mortgage or Rent		
Home or Renters Insurance		
Debt Payments		
Car Payment		
Car Insurance		
Parking, Tolls, Public Transit, and Gas		
Health Insurance		
Cable, Internet, and Phone		
Cell Phone		

Continued

Daycare, Babysitting, and Eldercare		
Groceries		
Pet Care		
Gym Membership		
Utilities, Gas, Electric, and Water		
Services, Lawn, Cleaning, and House Costs		
Other		

VARIABLE EXPENSES	PARTNER 1	PARTNER 2
Dining Out		
Shopping		
Subscriptions		
Movies, Music, and Events		
Travel and Vacation		
Hobbies		
Other		

TOTAL MONTHLY EXPENSES

Now that you have an overview of your total monthly expenses, subtract those figures from your monthly income. If your emergency fund is fully stocked, and there aren't other pressing financial goals you're aiming to reach at the moment, then you might feel comfortable putting your leftover monthly income into your wedding fund. It's not likely that you'll put every spare cent toward it, but this is a good way to determine how much you could save for your big day if needed.

PARTNER 1 TOTAL INCOME	MINUS	PARTNER 1 TOTAL EXPENSES	EQUALS	TOTAL POTENTIAL SAVINGS
	–		=	

PARTNER 2 TOTAL INCOME	MINUS	PARTNER 2 TOTAL EXPENSES	EQUALS	TOTAL POTENTIAL SAVINGS
	–		=	

WEDDING FUND WORKSHEET

The quickest way to blow your budget is by booking vendors or services before you have the vision and budget in place. It's very important to know how much you have to spend before you go spending it.

Use this worksheet to keep track of the various monetary offerings, where the funds are coming from, what they should be used for, and when to expect them. Transfer the figures you calculated from the Couple Contributions worksheet (see page 21) to this overall budget spreadsheet to get your combined total budget.

CONTRIBUTOR	MONETARY AMOUNT	EXPECTED DATE OF RECEIPT	CONTRIBUTION FREQUENCY (ONE-TIME OR MONTHLY)	METHOD OF DELIVERY (CASH, CHECK, DIRECT PAYMENT TO VENDOR)	FOR WHICH WEDDING CATEGORIES (CEREMONY, RECEPTION, DRESS, PHOTOGRAPHY, ETC)
Partner 1's Savings					
Partner 1 Monthly Contribution					
Partner 2's Savings					
Partner 2 Monthly Contribution					
Partner 1's Family					
Partner 2's Family					
Other					
Other					
Other					
TOTAL WEDDING BUDGET					

AVERAGE WEDDING BUDGET

All weddings are unique snowflakes, just like the couples who are getting married. Most resources will try to convert your budget into a list of percentages that you should expect to earmark for different areas of your wedding. The truth is, your budget and the portion you spend on each aspect of your wedding will vary depending on your priorities.

For example, traditional wedding budgets say you'll spend 8 percent on your attire. For a $30,000 wedding, that would be around $2,400. If you're working with a $10,000 budget and that same percentage, you would expect to spend around $800. You may decide that you're happy to buy a dress or suit off the rack at a department store and come in under budget for your attire, so you can easily allocate that money to another area that you care more about.

It can be helpful to have a basic breakdown of how to divide your costs, even if the rules don't necessarily apply to couples working with smaller budgets. The charts below show the most common breakdown of costs among the various aspects of a traditional wedding and a modified version for those working with a smaller total amount.

TRADITIONAL WEDDING BUDGETS

Reception (REC) **50%**, Photography (PHO) **10%**, Flowers and Decor (FLW) **8%**, Attire (ATT) **8%**, Entertainment (ENT) **8%**, Miscellaneous (MIS) **8%**, Ceremony (CER) **2%**, Stationery (STA) **2%**, Transportation (TRN) **2%**, Gifts (GFT) **2%**

MODIFIED BUDGETS FOR UNDER $20K

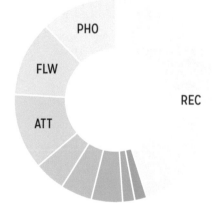

Reception (REC) **45%**, Photography (PHO) **12%**, Flowers and Decor (FLW) **12%**, Attire (ATT) **12%**, Entertainment (ENT) **5%**, Miscellaneous (MIS) **5%**, Ceremony (CER) **5%**, Stationery (STA) **2%**, Transportation (TRN) **0%**, Gifts (GFT) **2%**

REAL WEDDING BUDGETS

Before you get stressed and worry how you can possibly get all of this done on your budget, let's get some insight from couples who've gone before you. Check out the charts that follow to get a peek into how these real-life couples pulled off their weddings on reasonable budgets!

$5,000 BUDGET

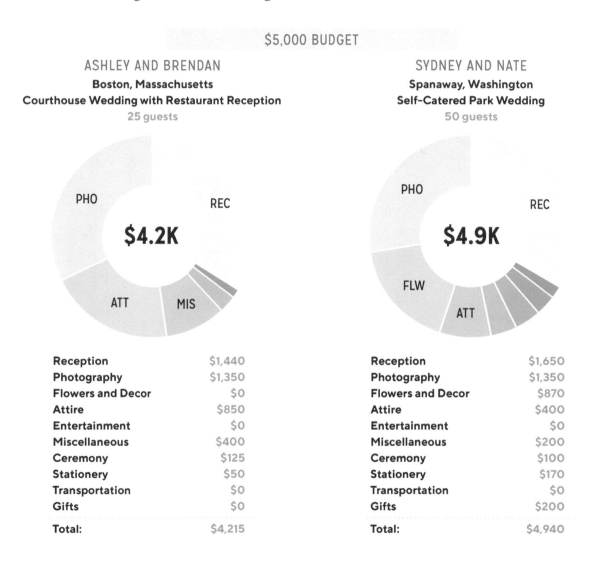

ASHLEY AND BRENDAN
Boston, Massachusetts
Courthouse Wedding with Restaurant Reception
25 guests

$4.2K

Reception	$1,440
Photography	$1,350
Flowers and Decor	$0
Attire	$850
Entertainment	$0
Miscellaneous	$400
Ceremony	$125
Stationery	$50
Transportation	$0
Gifts	$0
Total:	$4,215

SYDNEY AND NATE
Spanaway, Washington
Self-Catered Park Wedding
50 guests

$4.9K

Reception	$1,650
Photography	$1,350
Flowers and Decor	$870
Attire	$400
Entertainment	$0
Miscellaneous	$200
Ceremony	$100
Stationery	$170
Transportation	$0
Gifts	$200
Total:	$4,940

JAYME AND DON
Ionia, Michigan
Winter Church Wedding with Brewery Reception
110 guests

PHO

ATT

$9.9K

REC

Reception	$7,030
Photography	$2,000
Flowers and Decor	$50
Attire	$490
Entertainment	$0
Miscellaneous	$0
Ceremony	$100
Stationery	$75
Transportation	$0
Gifts	$175
Total:	$9,920

WHITNEY AND TATE
Morrilton, Arkansas
Woodland Wedding at a State Park
100 guests

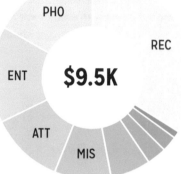

PHO

REC

ENT

$9.5K

ATT

MIS

Reception	$3,250
Photography	$1,600
Flowers and Decor	$610
Attire	$1,130
Entertainment	$1,450
Miscellaneous	$880
Ceremony	$100
Stationery	$250
Transportation	$0
Gifts	$275
Total:	$9,545

$10,000 BUDGET

ASHLEY AND JOSH
New York, New York
Central Park Ceremony with Restaurant Reception
26 guests

$15,000 BUDGET

VANESSA AND JACOB
Sterling, Illinois
Country Club Dessert-Only Wedding
300 guests

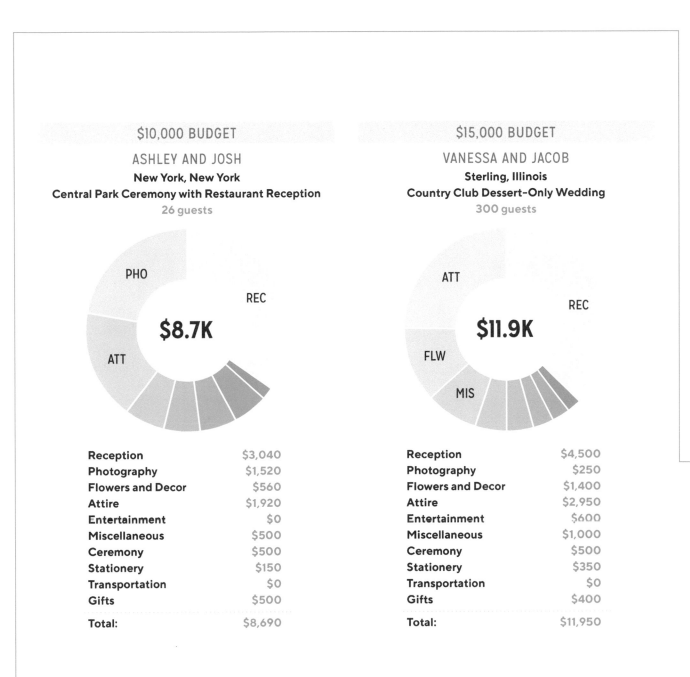

$8.7K — PHO / REC / ATT

$11.9K — ATT / REC / FLW / MIS

	$10,000 Budget		$15,000 Budget
Reception	$3,040	Reception	$4,500
Photography	$1,520	Photography	$250
Flowers and Decor	$560	Flowers and Decor	$1,400
Attire	$1,920	Attire	$2,950
Entertainment	$0	Entertainment	$600
Miscellaneous	$500	Miscellaneous	$1,000
Ceremony	$500	Ceremony	$500
Stationery	$150	Stationery	$350
Transportation	$0	Transportation	$0
Gifts	$500	Gifts	$400
Total:	$8,690	**Total:**	$11,950

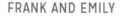

$15,000 BUDGET

CHAMISE AND DARREN
Brentwood, Tennessee
Church Wedding with Country Club Reception
150 guests

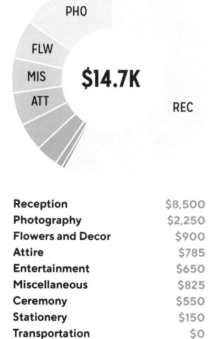

Reception	$8,500
Photography	$2,250
Flowers and Decor	$900
Attire	$785
Entertainment	$650
Miscellaneous	$825
Ceremony	$550
Stationery	$150
Transportation	$0
Gifts	$100
Total:	$14,710

FRANK AND EMILY
San Francisco, California
City Hall Wedding with Restaurant Reception
50 guests

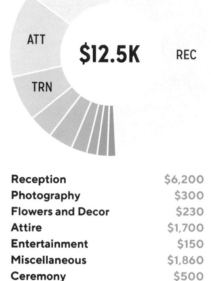

Reception	$6,200
Photography	$300
Flowers and Decor	$230
Attire	$1,700
Entertainment	$150
Miscellaneous	$1,860
Ceremony	$500
Stationery	$200
Transportation	$900
Gifts	$500
Total:	$12,540

THE BUDGET-SAVVY
WEDDING PLANNER & ORGANIZER

$20,000 BUDGET

STEPHANIE AND SCOTT
San Diego, California
Industrial Chic Warehouse Wedding
115 guests

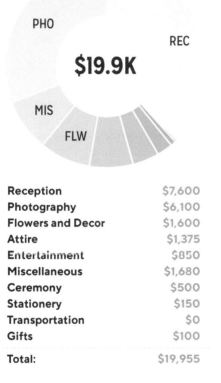

$19.9K

Reception	$7,600
Photography	$6,100
Flowers and Decor	$1,600
Attire	$1,375
Entertainment	$850
Miscellaneous	$1,680
Ceremony	$500
Stationery	$150
Transportation	$0
Gifts	$100
Total:	$19,955

JAMIE AND CODY
Jordan, Minnesota
Summer Orchard Wedding
300 guests

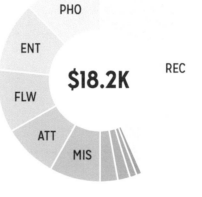

$18.2K

Reception	$7,900
Photography	$2,200
Flowers and Decor	$1,850
Attire	$1,550
Entertainment	$2,000
Miscellaneous	$1,500
Ceremony	$150
Stationery	$350
Transportation	$200
Gifts	$500
Total:	$18,200

THE BUDGET

YOUR WEDDING BUDGET BREAKDOWN

This detailed wedding budget worksheet allows you to record estimated and actual spending for various aspects of your big day. Feel free to cross out items that you aren't including in your wedding plans.

ITEM	BUDGETED COST	ACTUAL COST	OVER/UNDER BUDGET?
Attire			
Partner 1 (including accessories and alterations)			
Partner 2 (including accessories and alterations)			
Hair and Makeup			
Other			
Flowers			
Bridal Party Flowers			
Family Flowers			
Ceremony Flowers			
Centerpieces			
Miscellaneous Flowers			
Other			

Notes

ITEM	BUDGETED COST	ACTUAL COST	OVER/UNDER BUDGET?
Video and Photo			
Photography			
Videography			
Other			
Stationery			
Save-the-Dates			
Invitations			
Postage			
Programs			
Other			
Ceremony			
Day-Of Coordinator			
Officiant			
Venue Fee			
Decorations (nonfloral)			
Rentals			
Music			
Marriage License			
Transportation			
Other			

Notes

Continued

ITEM	BUDGETED COST	ACTUAL COST	OVER/UNDER BUDGET?
Reception			
Venue Fee			
Catering			
Musicians or DJ			
Sound and Lighting			
Bartender			
Liquor and Beverages			
Wedding Cake			
Tent Rental			
Decorations (nonfloral)			
Table Rental			
Chair Rental			
Linen Rental			
Guest Book			
Transportation			
Other			
Gifts and Favors			
Bridesmaid Gifts			
Groomsmen Gifts			
Parent Gifts			
Favors			
Other			

Notes

Ways to Save

There are tips for saving money on various aspects of your wedding peppered throughout this book, but I also want to share ways to *save up* for your wedding! Check out these ideas:

CREATE AN AUTOMATIC SAVINGS PLAN. Set up an automatic savings plan to transfer funds into your separate wedding bank account. You'll be able to save without even thinking about it!

CUT DOWN ON YOUR MONTHLY EXPENSES. Find areas in your personal spending that you can eliminate or cut back in order to put that money toward your wedding fund.

PICK UP EXTRA WORK OR TAKE ON A SIDE HUSTLE. If you don't have much extra room in your budget to save toward your wedding, consider taking on a part-time job or starting a side hustle to make extra cash.

BE A SAVVY SHOPPER. Whether you're shopping for decor for your wedding or just your weekly groceries, find ways to save money by taking advantage of promos, coupons, and sales.

TURN YOUR CLUTTER INTO CASH. Take a look around your home and identify items you're not using anymore to sell them for extra money. Try out apps like LetGo, eBay, or Poshmark.

The Guest List

THE WHOLE POINT OF having a wedding is to celebrate with the people who mean the most to you. Ideally, you'll want all your favorite folks around you celebrating your love. If the number of loved ones is quite large, you may find yourself in need of a guest list trimming.

While slashing the guest list can yield savings, don't pull out your red pen just yet. Your headcount may affect your budget, but the number of guests you invite does not always dictate how much you'll spend. Tiny budgets and large guest lists are not mutually exclusive. The more people you host, the further you'll need to stretch your money. Keeping things intimate could allow you to treat your guests to a nicer experience, but a smaller wedding does not guarantee a lower cost.

Coming up with the perfect balance of people to invite can be a real challenge, especially when there are expectations to manage and obligations at play. If you're struggling along the way, take time to reference your wedding goals and priorities from The Vision.

Use the worksheets and questions in this section to help guide your guest list decisions and avoid any invite dilemmas!

SAVVY TIPS

1. REMEMBER YOUR GOALS AND PRIORITIES. Think back to the vision you had for your day. Did you picture a big, packed banquet hall or an intimate, seated dinner? Your guest count should reflect your vision, priorities, and goals.

2. IDENTIFY THE VIPS. Start by making a list of all the must-haves, nonnegotiables, and favorites. This will likely include your immediate family, grandparents, other close loved ones, and your besties. These folks will be invited no matter what.

3. FACTOR IN YOUR BUDGET. Keep in mind that the more people you add to your list, the further your funds will have to stretch. Consider the cost per head based on your total desired wedding budget.

4. HAVE A SYSTEM FOR CUTS. Have a list of requirements or qualifiers to consider as you decide whom to invite. The exercise on the next page will help you trim the list.

5. BE FLEXIBLE. If you've got huge families to invite and the size of your list is too difficult to reduce, you'll just have to be flexible. You may have to make sacrifices in other areas to keep costs in check.

DISCUSSION QUESTIONS

Having a guest list guideline is a great way to make decisions when you're caught up in obligations. Ask yourselves these questions to determine whether or not to extend each person an invitation.

1. Have we spoken to this person in the last year?

2. Do we have a close personal or family connection with this person?

3. Will not inviting this person cause any sort of family or personal drama?

4. Will this person make our wedding more fun?

5. Will this person be part of our life as a couple?

YOU'RE INVITED!

If you're still feeling stuck on who should or should not be included in your guest list, use this handy flowchart. This system will walk you through important factors to consider and people to remember when building out your guest list.

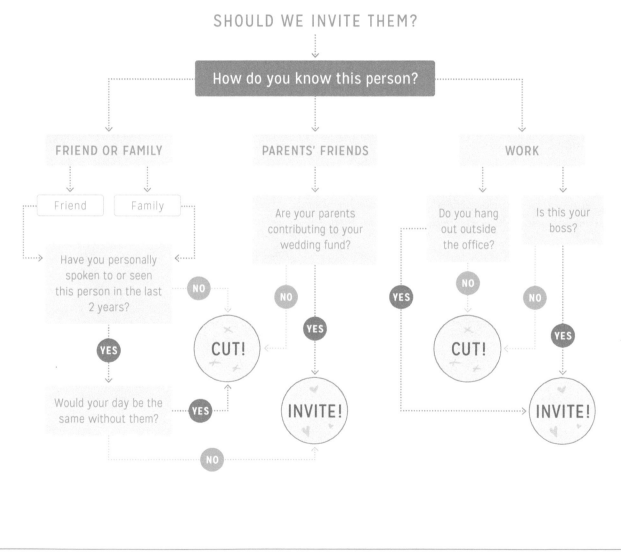

SHOULD WE INVITE THEM?

How do you know this person?

FRIEND OR FAMILY — PARENTS' FRIENDS — WORK

Friend — Family

Have you personally spoken to or seen this person in the last 2 years?

Are your parents contributing to your wedding fund?

Do you hang out outside the office?

Is this your boss?

NO — YES — NO — YES — NO — NO — YES

CUT!

INVITE!

CUT!

INVITE!

Would your day be the same without them?

YES — NO

Ways to Save

While a smaller guest list doesn't necessarily equal a smaller price tag, if you're looking to reduce costs across the board, consider cutting these people from your list:

ANYONE YOU'VE NEVER MET. If neither of you has met a potential invitee, nix that person. No total strangers at your wedding, even if they are your parents' friends.

CHILDREN OF FAMILY OR FRIENDS. Allowing kids at your reception can quickly bloat your guest count. Feel free to have an adults-only wedding celebration.

GHOSTS OF FRIENDSHIPS PAST. A good guideline to follow is not to invite any friends you haven't seen or spoken to in the last year. If you haven't made the time, they probably aren't that important to you.

PITY, OBLIGATION, OR GUILT INVITES. Each person you invite should be someone you are excited and happy to have celebrating by your side. Feel free to cut anyone who's on the list because you feel like you "should" invite them, but you don't actually want them there.

PLUS-ONES FOR SINGLE FRIENDS. Friends who have been dating someone for less than a year do not get a plus-one. If they aren't rocking their own engagement bling or cohabitating, their significant other gets the axe.

COWORKERS. If you happen to have a large number of coworkers, it might just be easiest to leave them all off the list. Include only coworkers that you hang out with outside of the office, as indicated in the You're Invited! flowchart.

POTENTIAL GUEST LIST

Use the following pages to jot down names of all the people you potentially would like to invite to your wedding. Be sure to ask both families for a list of possible people to include, and have them specify which of their nonfamily additions they would consider essential. Remember, this isn't a firm list. You just want the full picture of every person who could potentially be invited so you can trim it down from there.

Once you've listed everyone you're considering, go through and place a star by all your VIPs—the people you can't imagine your wedding without. Then, highlight the people you would be legitimately sad to not have at your celebration. Use a red pen to cross out anyone who doesn't make it through the guest list guideline or the elimination list. It's okay to get a bit messy; the Final Guest List follows immediately after. Use this area to really hone the list to a place where you feel comfortable with who has made the cut and who hasn't.

Partner 1's List

Partner 2's List

Partner 1's List Partner 2's List

... ...
... ...
... ...
... ...
... ...
... ...
... ...
... ...
... ...
... ...
... ...
... ...
... ...
... ...
... ...
... ...
... ...
... ...
... ...
... ...
... ...
... ...
... ...
... ...
... ...
... ...
... ...
... ...
... ...
... ...

Partner 1's Family's List

Partner 2's Family's List

Partner 1's Family's List

Partner 2's Family's List

FINAL GUEST LIST

Use this space to write down your final guest list
and tally up your total number of invites!

Partner 1's List

Partner 2's List

Partner 1's List

..
..
..
..
..
..
..
..
..
..
..
..

Partner 2's List

..
..
..
..
..
..
..
..
..
..
..
..

Partner 1's Family's List

..
..
..
..
..
..
..
..
..
..

Partner 2's Family's List

..
..
..
..
..
..
..
..
..
..

Partner 1's Family's List

..

..

..

..

..

..

..

..

..

..

..

..

..

..

..

..

..

..

..

..

..

..

..

..

..

..

Partner 2's Family's List

..

..

..

..

..

..

..

..

..

..

..

..

..

..

..

..

..

..

..

..

..

..

..

..

..

..

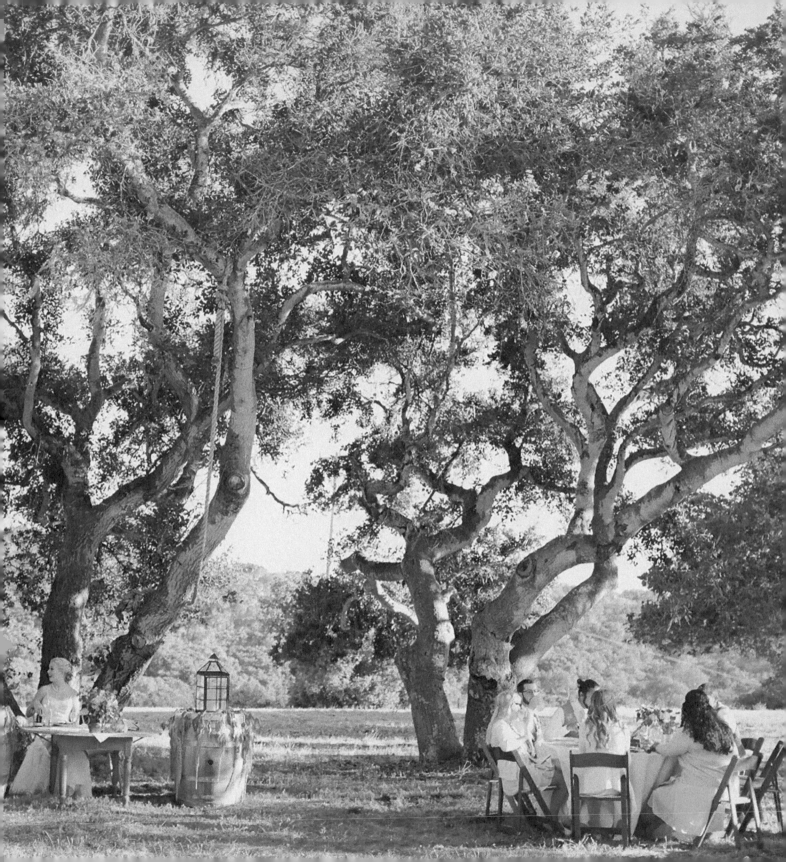

The Venue

AFTER YOU'VE NAILED DOWN your vision, your budget, and your tentative guest list, the next thing you should tackle is the venue or venues. Choosing where you'll exchange your vows and celebrate your union is a big decision and should be given the proper amount of thought. Your venue and the associated costs of rentals will likely make up a large chunk of your spending. You want to choose a site that is not only beautiful and functional but also within your budget.

There's no sugarcoating it: Finding a location with the perfect mixture of attributes is going to take some time and research. Before you get started, you should have a tentative date or at least month in mind to help you narrow your options. To give yourself the best chance of securing the perfect venue, try to be flexible.

You'll likely want to tour and gather information from several different locations; comparing venues will make the final decision easier. This chapter will help you navigate the research process, highlight important factors, and share must-ask questions so you can make the best choice for your big day!

SAVVY TIPS

1. REMEMBER YOUR VISION AND GOALS. Stay level-headed while researching and comparing venues by sticking to your vision and goals for your day. If you get overwhelmed or find yourself in a wedding-crazed spiral, take a moment to realign yourself with your priorities.

2. BE OPEN TO POSSIBILITIES. The truth is, you can get married pretty much anywhere, so keep your mind and options open to all the possibilities. You may opt for a traditional wedding hall or find yourself choosing something more outside the box. It's up to you and your partner to choose the setting that best suits your style and budget!

3. COLLECT DATA AND COMPARE. Get information about a few different venue options and compare them all thoroughly. You'll want to outline the complete cost of each location to get the most accurate baseline to analyze. The questions and tips in the following pages will help you make the best choice based on the data.

4. READ THE FINE PRINT. Renting a venue of any sort will likely require signing a pretty in-depth contract. Be sure to read through all of the policies and fine print to make sure you are fully aware of all rules and restrictions that apply to your rental agreement.

5. CONSIDER THE LOGISTICS. Think through all the details surrounding your venue choice and its impact on your guests. Suitable restroom facilities, ample parking, and appropriate accessibility are all necessary for the convenience and comfort of your guests.

DISCUSSION QUESTIONS

Let's figure out what sort of venue is the best fit for your big day. To get the process started, ask yourselves the following questions and discuss your answers with each other.

1. Do we want separate ceremony and reception locations, or would a single venue be preferred?

2. Do we picture exchanging our vows inside or outside?

3. Is it important to us for our ceremony to occur in a place of worship?

4. Are we flexible with our wedding date based on a venue's availability?

5. Are there any venue deal breakers that would nix a location immediately?

6. Is there anything specific we've dreamed about in terms of a wedding venue?

7. How much control do we want to have over the design, logistics, and arrangements of the day?

8. What is the vibe or feeling we want our wedding to have, and how does that translate to a potential location?

9. Do we have access to any properties or locations via family or friends that we could use in lieu of a traditional venue?

Two Birds, One Stone: Choosing a Dual-Purpose Venue

One way to save some cash and headaches is to choose a venue that can accommodate both your ceremony and reception. When you're on a budget and planning to do as much as possible yourself, this simple choice can spare you from a whirlwind of added logistics and extra fees, not to mention time.

Just think of it this way: Two venues yield double the contracts, details, delivery sites, and more. You'll also have to arrange for transportation between the two different spots. Additionally, note that the time it takes to travel between locations could be better spent celebrating with your loved ones.

YOUR DREAM CEREMONY WORKSHEET

Take some time to reference your wedding vision that we outlined in The Vision. Use the selections you chose to guide you through researching potential venues for your big day. It's important to keep these key points in mind, so transfer the options you've chosen or set based upon your wedding goals, priorities, and vision.

Approximate guest count: Location type:

Desired style: .. Total cost: ...

When dreaming of your venue, there are some other things you should consider when it comes to your ceremony:

SEATING ARRANGEMENTS: Pews, chairs, bales of hay, benches, or picnic blankets? A lot of objects can be used for seating. Would you like straight rows of seating, a curved arrangement, or stadium-style seating? Record your vision here: ...
..
..
..
..

CEREMONY LENGTH AND PERSONALIZATION: Do you want a deeply emotional and meaningful ceremony, or would you rather have something short and sweet? Record your vision here: ...
..
..
..
..
..

ALTAR ARRANGEMENTS: Do you picture yourselves exchanging vows on a stage, under an arch covered in flowers, in front of a colorful backdrop, or under a majestic oak tree? Record your vision here:
..
..

RITUALS: Are there any mini ceremonies or rituals you'd like to include, like a sand ceremony, handfasting, jumping the broom, smashing the glass, or others? Record your vision here: ...
..
..

MUSIC AND READINGS: Are there any special songs, poems, or readings that you'd like to include in your ceremony? Record your vision here:
..
..
..

YOUR DREAM RECEPTION WORKSHEET

Again, please reference your wedding vision that you filled out in The Vision to inform the decisions that you are making in this worksheet. Use the attributes you chose to guide you through researching potential venues for your big day. Keep these key points in mind.

Approximate guest count:

Location type:

Desired style:

Total cost:

When dreaming of your wedding reception, consider the following prompts to further develop your vision for your day:

SEATING ARRANGEMENTS: What sort of tables do you picture? Round, square, or rectangle? What sort of chairs? Or do you envision a cocktail-style reception with bistro tables and lots of mingling? Record your vision here:

...

...

...

FOOD AND BEVERAGE: Seated dinner, passed hors d'oeuvres, or buffet style? Open bar, beer and wine, or no alcohol? Record your vision here:

...

...

...

ENTERTAINMENT: Do you picture an epic dance party or just gentle background music? Is live music important to you, or would you be satisfied with a DJ? Would you

consider DIYing your wedding reception music with your own playlist? Record your vision here:

...

...

DECOR: Do you envision loads of flowers? Or rustic accents? Balloons, streamers, or candles? Gather some decor ideas and inspiration for your reception space. Record your vision here:

...

...

SPECIAL ADDITIONS: Are there certain features you'd like to include in your reception? These may include things like photo booths, lawn games, or a hot cocoa bar. Record your vision here:

...

...

...

MUST-ASK VENUE QUESTIONS

Be sure to ask potential venues the following questions.

Dates

- What dates do you have available in our desired month?
- Does the venue allow multiple wedding bookings per day?
- Is the venue available for exclusive use? Does that cost extra?

Logistics

- Can the venue accommodate both a ceremony and reception? If so, is there a cost difference for one, the other, or both?

IF YES

- What is the setup for a shared ceremony and reception space?
- If a portion of the venue needs to be transitioned from ceremony to reception, does the venue handle that transition?
- How many guests does the venue hold?
- What is the seating arrangement?
- How long will we have access to the venue? Is there a charge for additional time?
- When can we get access to the space to decorate and set up?
- Is the site handicap accessible?
- How many parking spots are available?

- Is there an overflow or rental lot if necessary?
- How many restrooms are there?
- How early can vendor deliveries be made?
- How long do we have to clean up and tear down?
- Are there private rooms available to get ready or have alone time before or during the wedding?
- Are there indoor and outdoor options on-site?
- For outdoor venues, is there a backup plan for rain? Are there extra fees involved?

Policies and Restrictions

- Is there a required or preferred vendor list? Can we use other vendors?
- Are there restrictions for the photographer in terms of flash usage?
- Is there somewhere secure to store wedding gifts and cards?
- Are there any noise or music restrictions?
- Are there any alcohol restrictions?
- What are the restrictions for decor? (e.g., no hanging things from the ceilings, or restrictions on sparklers or confetti)

Music and Entertainment

- Can the venue accommodate a DJ or live band?
- Where does the entertainment typically set up?
- Do you have a sound system with speakers, or will that need to be rented separately?
- Do you have microphones for speeches?
- Can I hook up an iPhone or laptop to your sound system?
- Is there a dance floor, and if so, how large is it?

Rentals

- Are there samples of the rentals available to look at?
- Are there tables available? What are their size and shape? How many do you have available?
- What types of chairs are included or available, and how many are there?
- Are linens, plates, silverware, and glassware provided, or will we have to rent them separately or get them through our caterer?

Food and Beverage

- Is catering available on-site?

 IF YES

 - Can you accommodate special dietary requirements?
 - If using in-house catering, what is the tax and service charge?

 IF NO

 - If I hire my own caterer, are kitchen facilities available?

- Can I bring in a cake from an outside baker?
- Is there a cake-cutting fee?
- Does the venue have a liquor license?
- Does the venue allow us to supply our own alcohol?

 IF YES

 - Is there a corkage fee?

 IF NO

 - How is alcohol priced and is there a charge for bar staff?
 - Is there a bar minimum that must be met?
 - What is the average bar tab for a guest list of our size?

Staffing

- Is there an on-site venue coordinator? Are those services included in the rental fee?
- What services or duties does the venue coordinator perform?
- Will the venue coordinator serve as the day-of coordinator?
- Is there a setup and teardown service available? How much does it cost?

Money, Payments, Permits, and Insurance

- What does the rental fee include?
- Are there discounts for off-season dates or days other than Saturday?
- How much is the deposit and when is it due? When is the balance due?
- What forms of payment do you accept?
- What is your cancellation policy? Is our deposit refundable in case of cancellation?
- Do we need event insurance or any special permits?
- Does the venue have liability insurance?

COMPARING VENUES

Use this worksheet to compile data from all the venues you are considering.

	VENUE 1	VENUE 2	VENUE 3	VENUE 4	VENUE 5
Venue Name					
Location					
Ceremony, Reception, or Both?					
Primary Contact					
Phone Number					
E-mail					
Website					
Hours of Use					
Rental Fee Includes:					
TOTAL COST					
Additional Notes					

THE VENUE

Ways to Save

CONSIDER NO- OR LOW-COST VENUE OPTIONS. Having your wedding at a family home or public place like a park is not only personal and meaningful, but it's also savvy! Imagine how much more you can do with your budget if you score your venue for free. Don't forget to factor in the cost of rentals, though. You may also want to purchase event insurance to protect yourselves and your property, especially if serving alcohol.

SELECT A SITE THAT ISN'T IN NEED OF SPRUCING. Choosing a wedding location that has natural beauty will allow you to do less work and spend less money decorating. A gorgeous garden or a beautiful beachfront would make an incredible backdrop for your wedding and reception and doesn't need much in the way of decor to pull it off!

PICK A PLACE THAT'S DUAL-PURPOSE. When you get hitched and party in the same location, you'll save more than just money; you'll spare yourself the stress and headaches of extra logistics, details, contracts, and more. Booking a venue that can accommodate your ceremony and reception in one place will simplify your other planning tasks significantly.

CHOOSE AN OFF-DAY. By getting married midweek or out of the typical wedding season for the area, you'll likely save significantly. If you're looking to cut costs, consider tying the knot on a day other than Saturday. Take it even further by booking a Friday-night wedding in the winter, which is known for being the slowest season for weddings.

MORNING GLORY. Similar to planning an off-peak wedding day, you can potentially reduce your cost by bumping up your wedding to an earlier time of day. Especially if the venue in question hosts multiple weddings on the same day, opting for an early start time could get you a discount. Brunch, anyone?

GO SUPER LOW-KEY. If you and your partner don't want to deal with a ton of muss and fuss, and are happy having an intimate wedding, consider a courthouse wedding with a restaurant reception. The experience will be more of a dinner party vibe than a big, fancy event, and if that suits your style, you'll love it!

DO A REVERSE DESTINATION WEDDING. Instead of paying top dollar for a big-city wedding, urbanite couples can choose to go out to the country to reduce the overall cost of their

Continued

Ways to Save *Continued*

celebration. Things simply cost more in certain areas of the country, and major cities are the worst offenders. If you're not opposed to a little travel, this can save you bundles.

CHOOSE A VENUE THAT ALLOWS YOU TO BYOB. If you're not careful, one of the biggest wedding expenses can come in the form of a bar tab. Show your guests a good time on your own terms by finding a venue that allows you to purchase and supply your own alcohol. Having control over the per-bottle price for wine or liquor can save you big money.

SAVE BY ASSOCIATION. Check out the local legions, Rotary Clubs, and association halls in your area, as they are typically available for rent at a cheaper price than a more traditional wedding venue. If you have family who are members of any organizations that have their own union halls, consider exploring those options as well.

CONSIDER A FULL-SERVICE VENUE. Booking an all-inclusive venue can sometimes come with savings. These venues often provide the tables, chairs, linens, and other rentals, so their packages can be a great value. You'll have to compare all of your options fully to know for sure, but it's definitely worth looking into.

BOOKING YOUR VENUE(S)

Choosing your venue is a big piece of the puzzle, but if you break it down into these easy-to-follow steps, you'll get it all done with less stress.

- Gather inspiration for your venues
- Research venues online
- Schedule venue tours
- Ask Discussion Questions from page 52
- Record venue data in worksheet on page 55
- Compare costs, pros, and cons of each venue
- Make your venue decision(s)
- Sign venue contract(s) and put down deposit(s) to hold your date
- Create your wedding-day timeline and share it with the venue, making note of delivery times
- Pay final balance
- Get married!

OUR WEDDING VENUE

Use the space below to record the details of your final venue(s).

Ceremony Venue

Name	Location	Ceremony or Dual-Purpose?
Primary Contact	Phone Number	E-mail
Website	Hours of Use	Inclusions
Restrictions	Total Cost	Deposit Amount and Due Date

Balance Amount and Due Date

Additional Notes

Reception Venue

Name	Location	Same as Above?
Primary Contact	Phone Number	E-mail
Website	Hours of Use	Inclusions
Restrictions	Total Cost	Deposit Amount and Due Date

Balance Amount and Due Date

Additional Notes

SELECTING AN OFFICIANT

Once you've got your venue, you'll need to find someone to perform your ceremony. If you and your partner don't have a connection to a religious community, you will likely need to consider hiring someone to officiate your wedding. There are plenty of professional officiants for hire out there, but choosing the right one for you will come down to personal preference. You want to select a person you feel comfortable with and who understands your desires for your wedding.

You may decide to have a close friend or relative do the honor in lieu of hiring a pro. Getting ordained online can be relatively easy, but it depends on the state you're getting hitched in, so be sure to check out your local laws. Asking someone you know to officiate your ceremony will add another layer of personal meaning to your day, plus it can save you a good chunk of change. Use the following worksheet to help you decide whom to select as your wedding officiant.

Do we belong to a religious community? Yes No

Do we have a connection to a religious leader who we'd like to officiate our wedding? Yes No

 If Yes: Congrats! You have your officiant!

 If No: Move on to next questions.

Would we feel comfortable having someone we don't know well perform our wedding ceremony? Yes No

 If Yes: Research professional officiants. Ask your venue if they have a list of potential candidates to consider. Ask your friends for referrals.

 If No: Move on to next questions.

Who are some close friends who wouldn't make the cut for the bridal party but are still important to us?

Who are our dearest relatives?

..
..
..
..
..
..
..
..
..
..
..

..
..
..
..
..
..
..
..
..
..
..

Who would be confident speaking in front of a crowd? Who has the best insight into our relationship? *Circle the names of people who fit this description.*

Hooray! You've identified a good candidate(s) to officiate your wedding. Ask him or her to do the honor of marrying you. Be sure to tell the person how much they mean to you and how special it would be for him or her to be such a big part of your day.

WHAT TO DISCUSS WITH YOUR OFFICIANT

☐ The order of ceremony

☐ Whether the ceremony will be religious or nonreligious

☐ The officiant's service or travel fee

☐ Special arrangements or accommodations

☐ Desired ceremony length

☐ How emotional or personal you'd like the ceremony to be

☐ Key details about your relationship to give some context to prepare messaging (if hiring a pro you don't know well)

☐ Readings you'd like to include

☐ Music or songs you'd like to be played

☐ Prayers, sermons, or special messages you'd like to be shared

☐ Special inclusions, such as sand ceremony, communion, lighting candles, or other rites

☐ Whether vows will be self-written or selected from prewritten options

☐ The officiant's attire

☐ Whether the officiant should read from a book, binder, or folder

☐ When to review a draft of the ceremony to make tweaks and give final approval (in the month before the wedding)

☐ Time for the wedding rehearsal

cole

anella

sea
of
love

sea
of
love

cake

together with
their families
cole and
anella
invite you
to their
wedding
July 18, 2016
Maui hi

menu

Watermelon
goat cheese salad
Artisan bread +
french butter

Wild Salmon
Lemon caper sauce
Roasted turnip

Wedding cake
+ champagne

CHAPTER 5

The Invites

ONCE YOU'VE GOT YOUR venue booked, you can consider your wedding date officially confirmed and begin thinking about how you'll spread the news. Traditionally, couples have sent out costly professionally printed wedding invitations with numerous envelopes, vellum inserts, and a variety of enclosure cards with information for guests. Luxurious invitations with lots of inserts and add-ons can run anywhere between $5 and $10 dollars each. If you're looking for a more practical take on wedding invitations, you're in the right place.

Thanks to technology and the vast amount of resources online, getting the word out about your wedding plans doesn't require fancy printed invitations. There are many ways to inform your guests of your impending nuptials, so this is one area where you can save significantly. You may decide to go the digital route, order invitations from a supplier, or create your own wedding stationery. In this chapter, you'll find a variety of tips, advice, and how-tos for saving money on your wedding invitations as well as some technology-driven alternatives.

SAVVY TIPS

1. REMEMBER TO SEND SAVE-THE-DATES. If you've got more than six months until the big day, it's a good idea to send a save-the-date to give your guests a heads-up about your plans. If you're planning a destination wedding or a large number of your guests will have to travel to attend, advance notice will be especially appreciated.

2. DON'T BE SCARED TO DIY. You don't need to be or hire a professional designer to get gorgeous, high-quality wedding invitations. It can be surprisingly simple to create, customize, and print your own invites at home if you've got the time to tackle that sort of project.

3. CONSIDER DIGITAL OPTIONS. Thanks to the Internet and the variety of resources available, you've got some great options for communicating your plans via technology. From e-vites to custom wedding apps to text message alerts, there's a tech solution to help you keep your guests in the loop.

4. LESS IS MORE. If you're set on sending printed invites, edit out the extraneous elements to lessen your expenses. Opt for a postcard save-the-date and leave out the response card envelope, or choose to have guests RSVP online to cut unnecessary costs.

5. KEEP GUESTS UPDATED WITH A WEBSITE. Wedding websites are a great way to keep your guests informed without adding much cost. Your website can house all the pertinent information for your loved ones, and there are many free and simple options available to help you create one.

WEDDING WEBSITES

Creating a wedding website is an easy and affordable way to share the relevant plans and details of your big day with your guests. Many free resources are available online to help you set one up in a snap—no design knowledge or technical skills necessary.

Get started on your wedding website by deciding what information you'd like to include. Use the worksheets in this section to outline your content and decide which platform is best for you.

DISCUSSION QUESTIONS

1. How much money are we planning to spend on our invitations, stationery, and other similar items?

2. Do we have technical skills to build a wedding website ourselves?

3. How tech-savvy are the majority of our guests?

4. Would we consider sending digital-only invitations?

Wedding Website Dos and Don'ts

DO INCLUDE A SPACE TO RSVP ONLINE. If you're really looking to cut back on expenses for your big day, include a link to your wedding website on your invitation for your guests to RSVP. This eliminates the need for an extra RSVP card, envelope, and postage.

DON'T INCLUDE INFO ABOUT EXCLUSIVE EVENTS. Share details about the rehearsal dinner or day-after brunch only if these events are open to all guests. You don't want to rub anything in the face of guests who may not be invited to the other parties.

DO KEEP YOUR GUESTS' NEEDS IN MIND. The purpose of a wedding website is to share all the info your guests will need to know to attend your big day. Most will visit for the sole purpose of submitting their RSVP or to peruse your wedding registry, so don't agonize over making it fancy. It just needs to be functional!

DON'T FORGET TO MAKE IT MOBILE-FRIENDLY. So many people surf the Web from their smartphones, so making sure your website works well on mobile is a good idea. Most of the simple, template-based website options are optimized for mobile, so even if you're not a professional designer, you should be covered.

DO CHECK OUT FREE OPTIONS. Lacking the funds to put together a custom wedding website? There are great free alternatives out there. Check out the wedding websites offered by The Knot, WeddingWire, Minted, Zola, and more!

WHAT TO INCLUDE ON YOUR WEDDING WEBSITE

- A warm welcome from the happy couple
- Photo of the couple
- Your names
- Wedding date, time, and location
- Schedule of events
- Directions and maps
- Accommodations and room block information
- Wedding registry information and links

- Online RSVP
- Contact information for any questions
- Your love story (optional)
- FAQs for things like dress code, plus-ones, and other questions (optional)
- Points of interest in the area (optional)
- Information about the bridal party (optional)
- Additional photos (optional)

THE INVITES

SAVE-THE-DATES, INVITATIONS, AND ALL THINGS PAPER
(IF YOU DECIDE TO DITCH DIGITAL)

Regardless of whether you decide to go with paper goods or digital reminders, keep in mind that your save-the-date or wedding invitation is the first impression your guests receive of your big day. These items can carry your theme throughout all of your wedding elements from the save-the-date to the thank-you notes. Matching paper and digital details to your wedding theme can create a truly cohesive feel for your special day, making it more customized and luxurious. And stationery is one of the easiest things to DIY!

This next section gives you pointers if you choose to utilize paper goods. Whether you order your invites from a stationery company or create them yourself, your paper goods should set the tone, convey a theme or style, and inform the recipient of the fun that is to come!

Collecting Addresses

One struggle of the digital age is that nobody really sends each other letters or cards in the mail anymore. It's unlikely that you have an address book of all your loved ones' addresses at the ready. You could easily spend countless hours reaching out to contact each person to make sure you have his or her proper address on file. Thankfully, there are a couple of great ways to take advantage of technology to collect this info more efficiently.

GOOGLE SHEETS. Use Google's free tools to create a form that you can send to all your loved ones. It will automatically insert all responses into a spreadsheet that you can then use to manage your contacts'

information. Add extra columns to your final spreadsheet for RSVP tracking. You'll be able to access your Google Spreadsheet from any Internet-enabled device, which is super convenient.

POSTABLE.COM. Postable is an awesome and free service that you can use similar to the Google form but with many more built-in features. You create an account and send your link to anyone whose address you want, and it automatically appears in your Web-based address book. Bonus: You can use the service to send custom thank-you cards directly to your guests after the big day, too!

PAPER GOODS INSPIRATION WORKSHEET

Considering your vision for your big day, use this space to brainstorm creative ideas for your wedding paper goods.

THEME: Use the style words you identified in The Vision to brainstorm more deeply about your theme.

.

.

.

COLORS: Identify your color scheme.

.

.

.

.

MOOD AND TONE: Formal or casual? Serious or lighthearted? .

.

.

.

.

SEASON: Winter, spring, summer, or fall?

.

.

.

.

MOTIFS AND SYMBOLS: Think about motifs that suit your wedding theme or even personal symbols that are meaningful to you or your wedding location. Examples include anchors for a nautical wedding, leaves for a fall wedding, apples for a New York wedding, or a barn for a rustic wedding. Get inspired! .

.

.

.

.

.

.

MONOGRAMS: Perhaps you'd like to incorporate a monogram into your invitation design.

.

.

. .

Ways to Save

SHOP SEASONAL SALES. Most of the popular wedding retailers run amazing sales around the major holidays, so watch out for coupon codes and discounts if you're not keen on making your invitations yourself.

BE A DIY DESIGNER. If you want to save yourself some major cash, consider designing your own wedding stationery. Use a professional design program, like Adobe Illustrator, or check out free online platforms, like Canva or PicMonkey, to create your own custom design.

USE A TEMPLATE. Even if you're not a designer, you can find plenty of free and low-cost templates online that are easy to customize. Check out Etsy for thousands of affordable, downloadable wedding templates that you can use for your paper goods.

BUY IN BULK. If you're printing your own invitations for your wedding, buying paper in bulk can save money and help create a cohesive look. Purchase a ream of card stock in a single color and use the same paper for everything from your invites to your programs to your table numbers.

SIZE MATTERS. You might be tempted to go outside the box with your wedding invitations, but know that unusual sizes often require additional postage. Stick to a standard 5-by-7-inch invitation if possible.

WATCH THE WEIGHT. Keep an eye on the number of enclosures you include in your wedding invitation, as the total weight of your envelope will determine the postage. Leave out things like accommodations and directions; instead, direct your guests to your wedding website for more info.

SEND A POSTCARD. If you relish the idea of running to the mailbox to see who sent in their RSVP but still want to save money, consider sending a postcard RSVP. Postcards remove the need for an additional envelope, and the postage will be cheaper, too.

OPT FOR FLAT PRINTING. Choose to print your wedding invitations on your home printer, or if you take them to a print shop, choose flat digital printing for the most economical price. You'll be able to achieve most colors you desire without the expense of offset printing. If you opt for simple black and white, you'll save even more.

DO BUDGET-SAVVY CALLIGRAPHY. While professional calligraphy is absolutely gorgeous, it's a luxury that's typically out of reach for couples who are on a small budget. Get the luxe look for less by doing your own lettering or by printing your addresses onto your envelopes in a calligraphy-style font.

TO DIY OR NOT TO DIY?

Paper goods are one of the easiest areas to save money. With the plethora of downloadable templates and tutorials available online, it's completely doable even for the not-so-crafty couple. Use these questions to decide whether or not to DIY your wedding stationery.

Do we have time to tackle this project? (Between design, printing, trimming, and assembling, you should budget around 10 hours of time to complete.)

. .

Do we have access to a printer? .

. .

How important is this detail to our wedding values?

. .

Could we partially DIY our wedding paper goods?

. .

. .

Will DIY actually save us money? .

. .

What design software platforms are we comfortable working with? .

What tools will we need to purchase to create these projects (paper trimmers, craft punches, tape runners, etc.)?

. .

Which of the following options appeal to us? (Select all that apply, and be honest with yourselves.)

PRINTING OPTIONS

❑ Local print shop
❑ Online print shop
❑ Print at home

DESIGN OPTIONS

❑ Design our own
❑ Download a free template
❑ Purchase a custom digital design to print

EMBELLISHMENT OPTIONS

❑ Custom envelope liner
❑ Special enclosure
❑ Ribbons, jewels, or other accessories

TRIMMING AND ASSEMBLY

❑ Trimming by hand
❑ Taking to print shop for cutting

SAVE-THE-DATES: MUST-HAVE DETAILS

Save-the-dates are simply that: a notice of the date and city where
your wedding will take place. Don't feel the need to go overboard with
information. Just stick to the basics:

❏ Couple's names

❏ Wedding date and city

❏ Wedding website address

❏ A note that the invitation
will follow

WEDDING INVITATIONS: MUST-HAVE DETAILS

The invitations will be going out closer to the wedding date and should
include the following:

ESSENTIALS:

❏ Couple's names

❏ Wedding date and time of ceremony

❏ Venue name, city, and state

❏ RSVP instructions

❏ Reception details

OPTIONAL:

❏ Wedding website address

❏ Accommodations

❏ Directions

❏ Rehearsal dinner or day-after brunch details

Invitation Wording Examples

IF PARENTS ARE CONTRIBUTING TO THE WEDDING:

Mr. and Mrs. Robert Beasley

request the honor of your presence

at the marriage of their daughter

Pamela Anne

to

James Michael

son of Mr. and Mrs. John Halpert

IF THE COUPLE ARE PAYING FOR THE WEDDING:

Together with our families,

Leslie Barbara Knope and

Ben Michael Wyatt

request the pleasure of your company

at the celebration of our union

(If your parents' names aren't included,
use your last names.)

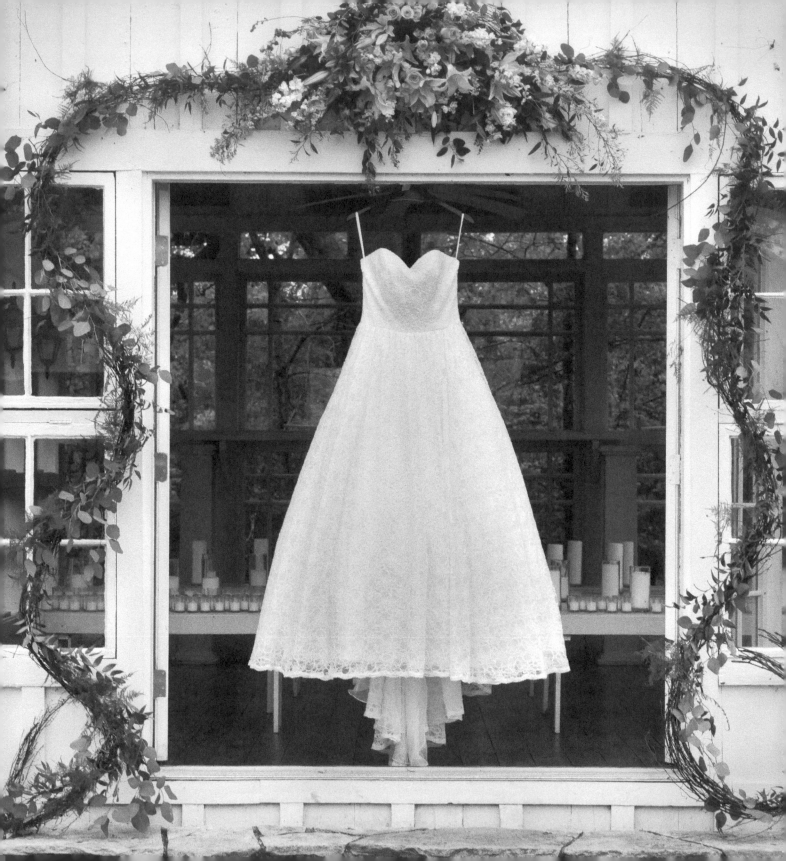

Your Wedding-Day Look

NOW THAT YOU'VE GOT the who, what, when, and where of your wedding day all set, it's time to nail down the how. As in, how will you look on your wedding day? Chances are you'll probably want to purchase something new and somewhat special to wear on your big day, but your attire doesn't have to come with a high price tag.

As far as wedding priorities are concerned, attire is one area that really affects or benefits only the person wearing it. When it comes to allocating your budget, you'd probably be better off funneling your finances toward items that will affect your guests' experience. The good news is there are plenty of ways to get dressed for less, which we'll explore in this chapter.

Whether you decide to rent, shop the sales rack, borrow, or buy used, you can get gorgeous gowns or tailored suits for your big day at a palatable price. Shopping for a wedding dress can be quite a unique experience, so keep these tips in mind to help you survive the process with your sanity intact.

SAVVY TIPS

1. START YOUR SEARCH EARLY. While your outfit isn't the most important aspect of your big day, starting your search early can ensure you get the best deal on the style you love. Rush fees can be pricey, so you're better off searching when things aren't so urgent. Dress shopping should ideally start at least six months before the big day, especially if shopping with a bridal salon that special-orders its gowns. The turn-around time can be up to 12 weeks, and you want to make sure you have plenty of time for alterations if necessary.

2. KEEP AN OPEN MIND. You may have a certain image in your mind of what you want to wear on your wedding day, but be sure to remain open to the possibilities. It never hurts to try something new—you might end up falling in love with something you never would've considered.

3. FIND A LOOK THAT SUITS YOUR VENUE. Keep your wedding venue in mind when choosing your big-day attire. If the celebration is happening outdoors in the summer, you'll want to avoid a long-sleeve gown. Don't choose something overly formal if you are having a more casual, laid-back affair.

4. SPLURGE ON ACCESSORIES. It can be hard to justify spending a ton of money on something you'll wear only once, so you may be better off choosing a simple gown. Instead, splurge on accessories that you can wear again and again, like jewelry or a fabulous pair of shoes.

5. COMFORT IS KEY. Remember, you'll be wearing this outfit for eight hours or more on your wedding day. Along with style, be sure to keep mobility in mind as well as weight. Choose something that you will feel comfortable and confident in for a long period of time.

6. BRING THE BEST SQUAD. Invite only a few VIPs to join you on your wedding dress search. You don't want to feel overwhelmed with too many opinions. Limit your helpers to the people whose opinions you value and trust the most. For many brides, those usually include mom, sister, and/or maid of honor.

7. WEAR SIMILAR SHOES. Be sure to have an idea of the type of footwear you want to wear on your wedding day, at least potential heel height. You'll want to bring a pair of similar height along to try on with the dresses so you'll get a better picture of the full effect.

8. ESTABLISH BUDGET BOUNDARIES. If you're visiting a salon or bridal shop, be sure to let your consultant know your budget so you don't get tempted by a pricey dress. Ask the consultant to only bring you gowns that are under your maximum budget to ensure you keep focused on dresses you can afford.

THE DRESS HUNT

It's only natural to want to look your best on your wedding day, but don't let yourself get too swept up in the moment. When you're working with a smaller budget, you might have fewer options to choose from, but it's definitely possible to get a beautiful dress at a price in the hundreds as opposed to the thousands. Before you start your hunt, use the following worksheets to narrow down your selections.

MUST-ASK QUESTIONS

If you're buying your dress from a traditional bridal salon, make sure you know the answers to these must-ask questions.

- Are there any trunk shows or sample sales coming up?
- Are alterations included in the price of the gown? How much will my alterations cost?
- How long will my dress take to arrive after I place my order?
- When is my full payment due?
- How many fittings will I need? Is there an extra cost?
- Do you offer a discount on bridesmaid dresses or accessories?

DRESS INSPIRATION WORKSHEET

Use this worksheet to identify your dress style. Remember to keep your budget for wedding attire in mind, for both you and your partner. No matter what is considered to be the best fit for your body type, pick whatever you feel the best in. It's your day.

Venue Type: .. Budget: ..

BODY TYPES

Apple

Full bust with a rounder midsection and hips

BEST DRESS STYLES FOR APPLE: A-line, Ball Gown, Empire

Pear

Narrow shoulders and small bust with wider hips
and more curves on the bottom

BEST DRESS STYLES FOR PEAR: A-line, Ball Gown, Empire

Rectangle

Shoulders and hips about the same width with little waist definition

BEST DRESS STYLES FOR RECTANGLE: Empire, A-line, Trumpet

Hourglass

Shoulders and hips about the same width with a well-defined waist

BEST DRESS STYLES FOR HOURGLASS: Mermaid, A-line

Long and Lean

Tall and thin from top to bottom

BEST DRESS STYLES FOR LONG AND LEAN: Mermaid, Sheath, Ball Gown

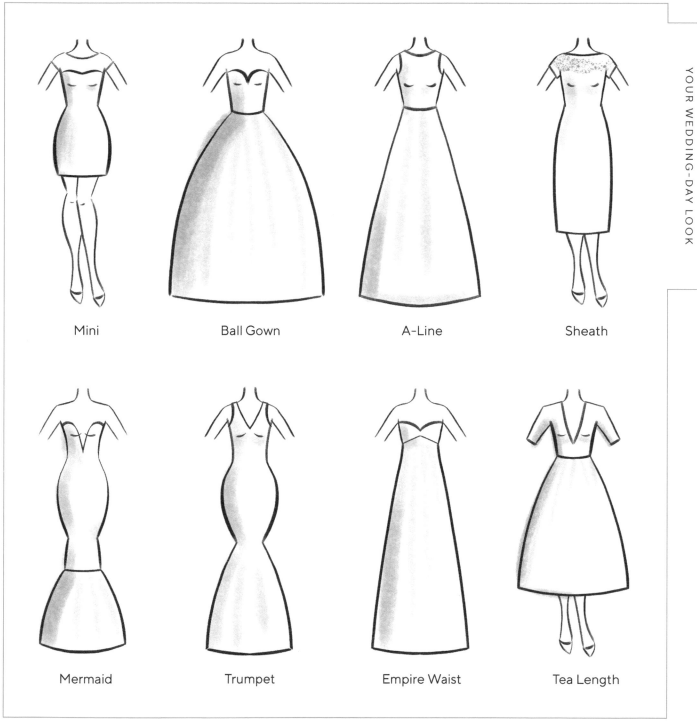

Mini Ball Gown A-Line Sheath

Mermaid Trumpet Empire Waist Tea Length

WHAT I LIKE

Print out or snip photos from magazines and tape them here to keep a record of looks you're loving. You can also create a Pinterest board to keep track of the dresses you adore.

DRESS TYPES

In this section, we will go over different silhouettes and other features that are common in wedding gowns. Circle options that you are most attracted to.

SILHOUETTES

A-line	Mermaid	Tea Length
Ball Gown	Mini	Trumpet
Empire Waist	Sheath	

STRAPS OR SLEEVES

Cap Sleeves	Short Sleeves	Strapless
Long Sleeves	Spaghetti Straps	Three-Quarter Sleeves
Petal Sleeves		

NECKLINES

Asymmetric	High Neck	Straight Across
Boatneck	Illusion	Sweetheart
Halter	Off-Shoulder	V-neck
	Square	

FABRICS

Chiffon	Organza	Silk
Cotton	Polyester	Taffeta
Lace	Satin	Tulle

Pro Tip: Before you go falling in love with something way out of your price range, pump the brakes and get grounded. Think back to your wedding budget that you calculated on page 30. Give yourself a maximum to spend based on the suggested budget percentages, but leave yourself a little wiggle room. You can easily move some money around between categories for small discrepancies, but it's harder to pull off multi-thousand-dollar reallocations. The best advice is to look only at dresses within your chosen budget to avoid obsessing over something that's out of reach.

KEEPING TRACK OF THE CANDIDATES

Keep track of the dresses you've tried, liked, and loved. Weigh the pros and cons to reach your final decision. Put a star next to or highlight your favorites.

Shop Name: ...

Location: ...

Appointment(s): ...

Dresses Tried on (Designer/Style/Price):

..

..

..

..

..

Shop Name: ...

Location: ...

Appointment(s): ...

Dresses Tried on (Designer/Style/Price):

..

..

..

..

..

Shop Name: ...

Location: ...

Appointment(s): ...

Dresses Tried on (Designer/Style/Price):

..

..

..

..

..

Shop Name: ...

Location: ...

Appointment(s): ...

Dresses Tried on (Designer/Style/Price):

..

..

..

..

..

Shop Name: ...

Location: ...

Appointment(s): ...

Dresses Tried on (Designer/Style/Price):

..

..

..

..

Shop Name: ...

Location: ...

Appointment(s): ...

Dresses Tried on (Designer/Style/Price):

..

..

..

..

Ways to Save

SHOP SAMPLE SALES. Check with your local bridal boutiques to find out when they typically host their sample sales. You can often get gently worn sample dresses for 50 percent off or more.

RENT THE DRESS. Check out the various online resources that offer gorgeous gowns for rent, such as Rent the Runway or Borrowing Magnolia. You could rock a designer frock for a fraction of the price of buying new.

BUY OFF THE RACK. Don't be scared to hit Macy's, Nordstrom, or even your local formal-wear boutique, where you can purchase a gown in-store. Buying off the rack is particularly helpful for those who are working with a shorter timeline, as you don't have to wait for a dress to ship.

PURCHASE A USED GOWN. Buying a preowned gown comes with significant savings, especially if you're interested in a luxe style. Check out sites like Nearly Newlywed or Once Wed to shop for dresses from brides who've gone before you.

WATCH OUT FOR SEASONAL SALES. The major bridal retailers tend to run fantastic promotions around the holidays, so keep an eye out for deals and discounts. For instance, David's Bridal hosts a $99 gown sale a couple of times a year, so you can score your dress for super cheap.

SHOP DEPARTMENT STORES FOR SUITS. Instead of going to a fancy suit shop, consider perusing your favorite department store for wedding-day duds. Many of the major chains have sales you can take advantage of. You'll likely get a better deal on something that can be reworn rather than rented.

SHOP IN THE OFF-SEASON. If you are planning to have a long engagement, take advantage of seasonal inventory clearance events. You can get winter suits at a deep discount during the summer months and vice versa, if your timeline allows.

CONSIDER ONLINE OPTIONS. You can score some great deals by shopping on the Web, but it's important to make sure the site you're buying from is reputable and has a flexible return or refund policy.

CHECK OUT VINTAGE AND THRIFT SHOPS. Whether you're looking for a suit or a dress, you could score a diamond in the rough by hunting through your local thrift and vintage stores. Not only could you get a fabulous deal, but you'll also get a one-of-a-kind style.

RESALE IS ALWAYS AN OPTION. If you set your sights on something particularly expensive, keep in mind that you can potentially recoup some of the costs after the big day. Reselling your wedding gown is always an option, and it could allow you to justify springing for your dream dress.

THE DRESS

Congratulations! You've found the one, the dress you'll wear on your wedding day. Record all the important details below.

Shop Name: ...

Style Name and Number:

Location: ...

Phone Number: ..

Primary Contact: ..
...

Expected Delivery Date:

Fitting Date(s): ..

Dress Price: ..

Alterations Price: ..

DRESS TO-DOS

- ☐ Determine your estimated dress budget
- ☐ Research styles and price points
- ☐ Do some online browsing and pin some style inspiration on Pinterest
- ☐ Narrow down styles, fabrics, and dresses that coordinate with your venue and overall plans
- ☐ Book appointments at bridal salons to try on dresses
- ☐ Take notes on styles you love most on yourself
- ☐ Do some online research—maybe you can find a gently used version of a dress online for cheaper

- ☐ Check out alternative options, like department stores
- ☐ Compare your options and make a final decision
- ☐ Order your dress, if necessary
- ☐ Make appointments for fittings, as necessary
- ☐ Buy accessories: veil or headpiece, shoes, undergarments, and others
- ☐ Have final fitting and get dress pressed or steamed
- ☐ Pick up your dress at least one week before your big day
- ☐ Put on that gown and rock your frock!

GROOM'S ATTIRE

From a formal black tuxedo to a casual beach-chic ensemble, styling for grooms really runs the gamut these days. When choosing your wedding day attire, you'll want to keep a few things in mind such as budget, style, and coordinating with your color scheme and wedding venue. The most important thing is that you choose a look that you feel comfortable and confident in.

INSPIRATION WORKSHEET

Use this worksheet to identify your suiting style. Remember to keep your budget for wedding attire in mind, for both you and your fiancé! Consider the following aspects of your wedding day look and use your vision and priorities to determine the best choice for you.

Circle the options that best describe your wedding day:

VENUE TYPE

Indoor Outdoor

COLOR PALETTE

Warm Cool Light Dark

WEATHER

Hot Warm Cool

VIBE

Casual Formal In-Between

TIE

Bow Tie Necktie No Tie

ACCESSORIES

Flashy Subtle

PERSONAL STYLE

Classic Clean Flashy Modern

FABRICS

Cashmere Linen Seersucker Tweed
Cotton Polyester Silk Wool

Continued

GROOM ATTIRE TYPES

TUXEDO: Black tie, white shirt, bow tie, satin trim, polished shoes

BEST FOR: Formal Weddings, Ballroom Weddings

BUSINESS SUIT: Typical, versatile suit that can be worn for a variety of occasions

BEST FOR: Any Wedding Style

SUIT WITH VEST: Typical suit with added vest for style. Three pieces in the same fabric.

BEST FOR: Hipster Weddings, Vintage Weddings

KHAKIS WITH VEST: Popular style for a more laid-back wedding. Typically worn with a shirt and tie, occasionally paired with suspenders.

BEST FOR: Casual Weddings, Backyard Weddings

MISMATCHED SUIT: Blazer or jacket matched with khakis or other dress pants

BEST FOR: Preppy Weddings, Casual Weddings, Outdoor Weddings

CASUAL SUIT: Lightweight fabric, typically light in color.

BEST FOR: Outdoor Weddings, Summer Weddings, Beach Weddings

Groom's Attire Budget: ...
..
..

STYLING TIPS

☐ Tailoring will help your suit look its best. Be sure to factor alterations cost into your budget.

☐ If you are short or stocky, avoid styles with excess fabric, long jackets, or high button lapels.

☐ Opt for two buttons over three.

☐ Use your accessories to add personality to your look.

☐ Be mindful of patterns and color when selecting your suit and accessories.

☐ Accessorize with a stylish tie, pocket square, cuff-links, and appropriate shoes. And don't forget about dress socks!

Renting vs. Buying

When it comes to your wedding day suiting, is it better to rent or to buy? Depending on your style and budget, it may be more economical to purchase something new rather than renting a tuxedo. Online rental sites like TheBlackTux.com and Menguin.com offer a simple platform to choose, rent, and return suits or tuxedos with the click of a mouse. Both have plentiful stylish options to choose from and rental prices are better than your typical local rental establishment.

If you decide to purchase your wedding day suit, opt for something that coordinates with your wedding style but isn't too flashy. You want to make sure you choose something that can be reworn for various occasions, whether for work functions or other weddings. If you're planning to buy, consider shopping for your suit at department stores during their seasonal sales. You can take advantage of yearly discounts and score a fabulous suit for less!

THE SUIT

Congratulations! You've found the one, the suit you'll wear on your wedding day. Use the space below to record any important details like delivery date and fitting schedules.

Shop Name: ..

Style Name/Number: ..

Location: ...

Phone Number: ..

Primary Contact: ...
...

Expected Delivery Date:

Fitting Date(s): ..

Suit Price: ...

Alterations Price: ...

ACCESSORIES

Your wedding-day attire isn't just about your dress or suit. Remember to think about all the smaller pieces of your wedding-day look, including the accessories. From jewelry to headpieces, cuff links to shoes, there are so many ways to accent your outfit. Just don't forget to leave room for these items in your budget!

ACCESSORIZE YOUR LOOK

Use the worksheet below to describe the different items you each plan to wear to accessorize your wedding-day look, including the price.

Headwear: ...

Jewelry: ...

Earrings: ..

Necklace: ...

Bracelet: ..

Ring: ...

Shoes: ...

Garter: ...

Clutch or Purse: ...

Sash or Belt: ..

Headwear: ...

Tie: ..

Cuff Links: ..

Tie Clip: ...

Lapel Pin: ...

Pocket Square: ...

Watch: ..

Belt: ...

Socks: ..

Shoes: ..

Ways to Save

BEG OR BORROW (BUT DON'T STEAL). Don't want to fork over your funds for fancy accessories? See what you can get on loan from family or friends. Heirloom items from loved ones also make for wonderful memories.

RENT YOUR ROCKS. Rather than purchasing your wedding-day jewels, consider renting them from Rent the Runway or Happily Ever Borrowed. Instead, splurge on something you'll wear again, like a fab pair of shoes.

ALWAYS SHOP SAVVY. Keep an eye on seasonal discounts and sales to score great deals on accessories. Make sure to check for coupon codes, free shipping offers, and more to get the best price.

CONSIDER DIY ACCESSORIES. You can easily stitch up a stunning sash or belt using inexpensive supplies from your local craft store, rather than blowing your cash on one from a bridal shop. You could also DIY your jewelry!

SKIP WHAT DOESN'T SUIT YOU. Don't want to wear a big fluffy veil with layers of tulle? You get to choose what feels best and most natural for you. It's important to be comfortable, so stay true to your personal style.

WEDDING-DAY BEAUTY

When it comes to your wedding-day look, don't forget about beauty. You'll want to decide how you want to wear your hair and makeup on your big day, so make a game plan for who will be prettifying your face. If money is extra tight, you might opt to make yourself up or recruit one of your besties to do it for you. Use this section to record those plans—and don't forget about the pre-wedding mani-pedi.

MAKING A BEAUTY PLAN

Take some time to peruse Pinterest to gather inspiration for wedding-day hair and makeup looks. Use this worksheet to make notes on your desired looks.

ASK YOURSELF THESE QUESTIONS:

Do I feel comfortable doing my wedding-day hair myself?

Do I feel comfortable doing my wedding-day makeup myself?

Do I have room in my budget to pay for hair and makeup?

Can any of my friends, family, or bridesmaids do my hair or makeup for me?

How do I plan to do my nails for my wedding day?

MAKEUP

... ...
... ...
... ...
... ...
... ...
... ...
... ...
... ...

HAIR

... ...
... ...
... ...
... ...
... ...
... ...
... ...
... ...

NAILS

... ...
... ...
... ...
... ...
... ...
... ...

Ways to Save

DO IT YOURSELF. You deal with your hair and face every day, so you probably know how you like to look. If you're the low-maintenance type or just really good at makeup, there's nothing wrong with doing it yourself!

GET A FREE MAKEOVER. Visit a local department store or Sephora and have one of the on-staff makeup artists give you a makeover. You can often get a complete beauty look if you purchase at least one item.

ASK A FRIEND. Perhaps one of your besties has major skills in the hair department. Ask a friend to do your hair for you so you can skip the expensive salon appointment.

PREP BEFORE THE BIG DAY. Give yourself a little pampering at home before the big day. Get inexpensive face masks, hair conditioning treatments, and more at your local beauty supply store to give yourself a great canvas.

SKIP THE PROS FOR THE BRIDAL PARTY. Chances are if you're on a tight budget, you won't have the funds to cover hair and makeup for your bridesmaids. Have them do their own wedding-day beauty or leave it up to them to pay for pros.

THE FINAL BEAUTY PLAN

Use this section to record the information for your wedding-day beauty plans. Feel free to print and tape or glue in photos of inspiration or from your hair and makeup trials.

Hair

Hairstyle: ...

Hair Stylist: ...

Location: ..

Phone Number: ...

Supplies Needed (if applicable):

...

...

Makeup

Look: ..

Makeup Artist: ..

Location: ..

Phone Number: ...

Supplies Needed (if applicable):

...

...

Nails

Look: ..

Nail Artist: ..

Location: ..

Phone Number: ...

Supplies Needed (if applicable):

...

...

RINGS

One important aspect of your big-day attire is the wedding rings that you and your partner will exchange at the altar. Rings are a more justifiable splurge because you'll likely be wearing them for the rest of your lives. For this reason, many couples consider this an expense that doesn't warrant factoring into your overall wedding budget. But the fact is, you'll still have to buy them, so it's important to consider the costs.

SAVVY TIPS

1. GET SIZED. You and your partner will want to know your ring sizes before you purchase your rings, especially if you choose to buy online. This is especially important if you choose a band style that isn't easy to alter.

2. FACTOR IN ENGRAVING. Many couples choose to have a special inscription engraved inside their wedding bands. Consider this addition when selecting your bands, not only in terms of space but also the potential added cost and time to receive them.

3. KEEP YOUR LIFESTYLE IN MIND. If you or your partner does a lot of work with your hands, you'll probably want to stay away from ornately designed rings or softer metals that are more likely to scratch.

COMPARING RINGS

Record the top four to six ring options you're considering for your wedding bands.

Size: ...
Style: ..
Shop Name: ..
Primary Contact: ..
Price: ..
Notes: ...
...
...
...

Size: ...
Style: ..
Shop Name: ..
Primary Contact: ..
Price: ..
Notes: ...
...
...
...

Size: ...
Style: ..
Shop Name: ..
Primary Contact: ..
Price: ..
Notes: ...
...
...
...

Size: ...
Style: ..
Shop Name: ..
Primary Contact: ..
Price: ..
Notes: ...
...
...
...

Size: ...
Style: ..
Shop Name: ..
Primary Contact: ..
Price: ..
Notes: ...
...
...
...

Size: ...
Style: ..
Shop Name: ..
Primary Contact: ..
Price: ..
Notes: ...
...
...
...

Ways to Save

BUY YOUR BLING ONLINE. Consider shopping from a reputable online retailer to score a massive discount. Many online-only shops have less overhead and therefore offer better prices, such as JamesAllen.com.

GO VINTAGE. Shop for your ring at vintage stores or thrift shops. You could end up with a piece of jewelry with major history and save yourself some cash in the process.

WATCH FOR SEASONAL SALES. If you're shopping at a typical jewelry retailer, keep an eye out for seasonal sales. Sometimes you can get deals if you buy both your bands together.

CHOOSE ALTERNATIVE METALS. Instead of splurging on platinum bands, consider something more durable and inexpensive, such as tungsten, cobalt-chrome, or titanium, for significant savings.

PICK A SIMPLE STYLE. The least expensive bands are those that are minimalist and simple. Choose a wedding band that is sleek and slim with few to no gemstones for the best possible price points.

THE WINNERS

Use the space below to record your ring details.

Partner 1's Ring: ...

Size: ...

Style: ...

Shop Name: ...

Primary Contact: ...

Delivery Date: ...

Price: ...

Partner 2's Ring: ...

Size: ...

Style: ...

Shop Name: ...

Primary Contact: ...

Delivery Date: ...

Price: ...

CHAPTER 7

The Wedding Party

CHANCES ARE WHEN YOU'VE pictured your wedding day, you envisioned your dearest friends or siblings standing beside you at the ceremony altar and celebrating with you on the dance floor at the reception. Having a wedding party can be super fun and special, but it can also add a heap of extra expenses to your big-day tab. If your budget is extra tight, you can opt for fewer attendants on each side or choose to skip the traditional bridal party concept entirely. Remember, being a participant in a wedding is not just an honor but also a big responsibility, and often an even bigger expense. You never know—your friends might be glad to be let off the hook!

For couples who have a substantial number of people they consider close friends, the act of narrowing down the guest list to a small group of folks can be daunting. You should make the choice that makes the most sense for you, even if it breaks tradition. Use the tips and worksheets in this chapter to figure out what the best option is for your situation, and proceed accordingly.

SAVVY TIPS

1. CONSIDER YOUR BUDGET. Yep, it always comes back to the Benjamins. Use your budget to help you decide whether or not you value the inclusion of a bridal party in your celebration. Weigh the expense per attendant, such as gifts, bouquets, boutonnieres, and the like. If that money could be better spent elsewhere, it's totally okay to skip the traditional attendants.

2. ANALYZE YOUR ASK. Asking someone to participate in your wedding is basically requesting that the person devote a significant amount of time and money to celebrating you. Keep this in mind if it may be asking too much of certain potential candidates, and be understanding if someone declines your invitation.

3. GIFTING GRACIOUSLY. The more people you include in your ceremony, the more folks you'll be buying gifts for. If you're on an extra tight budget, consider keeping your bridal party super small. Having fewer attendants will allow you to be more gracious and generous with your gratitude.

4. IGNORE OUTDATED TRADITIONS. It's becoming more and more common for attendants on both sides of the aisle to be mixed genders. If the bride's best friend is a guy, have him stand on the bride's side at the altar. The groom's sister should feel free to stand beside the groom as well.

5. DON'T GO OVERBOARD. Keep things simple to save yourself and your squad money. For example, from the bridal party proposal to the bridesmaids' luncheon to gifts, you can make practically everything special without spending much money.

DISCUSSION QUESTIONS

1. How large would we like our ideal wedding party to be?

2. Whom would we each choose as our best friends?

3. Do we have siblings we want to include in our bridal party?

4. Do we care about having a balanced number of attendants on each side?

5. Does our approximate budget for florals and gifts realistically fit with the size of our wedding party?

6. What do we expect of our bridal party during this process and on the day of the wedding?

7. Do the people we are considering have the time and funds to devote to this responsibility?

8. Will we still be close to each of these people in 10 years?

9. Do they support our marriage?

CHOOSING YOUR BRIDAL PARTY

After asking yourselves the questions in the previous section and narrowing down your choices, make your final wedding party selections. Use this space to record the info for each member of your bridal party.

	NAME	PHONE NUMBER	E-MAIL	CITY
Partner 1's Honor Attendant				
Partner 1's Attendant				
Partner 1's Attendant				
Partner 1's Attendant				
Partner 1's Attendant				
Partner 1's Attendant				
Partner 2's Honor Attendant				
Partner 2's Attendant				
Partner 2's Attendant				
Partner 2's Attendant				
Partner 2's Attendant				
Partner 2's Attendant				
Flower Girl				
Ring Bearer				

POPPING THE QUESTION

Once you and your partner have made your final bridal party selections, it's time to decide how to pop the question! Do you want to do something cute, funny, creative, or sentimental? Can you ask each one in person, or do some of them live far away? Remember, you don't have to spend a fortune or lavish them with expensive gifts. The important thing is to convey how much you treasure your relationship and how much it will mean to have this person beside you on your big day.

Check out these wedding party proposal options, choose the one that works best for you, and decide when you plan to do the honor:

Short and Sweet

- Compose a handwritten note telling them how much they mean to you.
- Call them up and ask them on the phone or via video chat.
- Download a printable card online with a clever message asking them to be in your wedding party.

Crafty and Cute

- Make a scrapbook about your friendship, with the last page asking them to be in your wedding party.

- Create a bridesmaid proposal box with a few goodies, like nail polish, lip gloss, a bath bomb, or other items.
- Put together a groomsmen box with a cigar, a cigar cutter, and a mini bottle of liquor.

Bubbly and Boozy

- Give them a mini bottle of champagne and a card.
- Ask them to be in your wedding party with a bottle of wine or their favorite booze wrapped in a customized label.
- Take them out and ask them over brunch or drinks.

Low Maintenance and Long Distance

- Send a small package with something edible, like a custom cookie or candy, and a cute note.
- Order something unique from Etsy and ship it to them.
- Send flowers with a note.

Simple and Sporty

- Invite them out for a drink or to take in a ball game.
- Gift them an engraved pocket knife or personalized cooler.
- Ask them to join your wedding "team" with a personalized jersey or hat.

BRIDAL PARTY ATTIRE

You've invited your besties to stand beside you—now you have to choose what they'll wear while they do so. Remember, just like when searching for your wedding dress or suit, it's important to keep your venue in mind as you choose your bridal party attire. You will want their outfits to coordinate well with yours and your partner's. Use the worksheet below to brainstorm possible wedding attire ideas for your bridal party and don't forget to include notes about colors.

WOMEN

Style? ...

...

...

Long or Short? ...

...

Matching or Eclectic? ...

...

Solid or Print? ...

...

Fabric Types? ...

...

Different Body Types? ...

Accessories? ...

...

Shoes? ...

...

MEN

Style? ...

...

...

Suit or Tux? ...

...

Jacket or No Jacket? ...

...

Shoes? ...

...

Socks? ...

...

Ties? ...

...

Shirts? ...

...

Pocket Square? ...

...

BRIDAL PARTY ASKS

Part of the reason a wedding party exists is to assist the happy couple with various tasks associated with the day. Think about what wedding duties you and your partner could use some help with, and ask a member of your bridal party to lend a hand. Record your decisions in the chart below.

MAID OF HONOR	BEST MAN	BRIDESMAIDS	GROOMSMEN
⬜ Plan bridal shower	⬜ Plan bachelor party	⬜ Help plan bridal shower	⬜ Help plan bachelor party
⬜ Plan bachelorette party	⬜ Sign marriage license	⬜ Help plan bachelorette party	⬜ Attend pre-wedding events when possible
⬜ Sign marriage license	⬜ Give a toast at reception	⬜ Attend pre-wedding events when possible	⬜ Help and support the groom when asked
⬜ Give a toast at reception	⬜ Carry the rings	⬜ Help and support the bride when asked	⬜ Speak at rehearsal dinner
⬜ Hold bride's bouquet at altar	⬜ Decorate wedding-night hotel room	⬜ Speak at rehearsal dinner	
⬜ Decorate wedding-night hotel room	⬜ Help and support the groom when asked		
⬜ Help and support the bride when asked			

Notes

Ways to Save

You may not be paying for your attendants' attire, but it's courteous to keep costs in mind when it comes to what you ask them to wear. Use these tips to save on outfits for your wedding party.

CHECK FOR BRIDAL SALON DISCOUNTS. If you purchase your wedding dress at a bridal salon, find out if they offer discounts on bridesmaid dresses as a courtesy.

BE A LAID-BACK BRIDE. If you're not into the traditional look for your bridesmaids, give them loose parameters and have them each pick their own dress. Feel free to provide them with a color swatch and fabrics to stick to in order to keep things consistent. This allows each bridesmaid to buy a dress at a price point she can live with.

SUGGEST A RENTAL. Renting a designer dress from Rent the Runway is a great way for your bridesmaids to get high-end style at a reasonable price. Consider having them rent their dresses—just make sure they reserve them far in advance for best availability.

KEEP FABRIC AND LENGTH IN MIND. A long dress is going to cost more than a short dress made of the same fabric. Additionally, fabric choice can also have an effect on the cost, so try to choose styles made from affordable but attractive fabrics, like chiffon.

CONSIDER NONBRIDAL OPTIONS. No one says you *have* to choose a bridesmaid dress or a wedding suit for your attendants. Check out options at department stores, boutiques, and more. You just might find affordable options to fit your wedding theme perfectly.

KEEP SHOES NEUTRAL. Give your attendants the option to wear neutral shoes they already own rather than asking them to purchase a new pair for the big day. Choose a basic color and ask everyone to wear that color shoe.

MIX AND MATCH. David's Bridal is known for having affordable dresses for brides and bridesmaids alike. Consider choosing a single color and fabric and allowing each gal to choose the style that complements her figure.

SUITS: BUYING OR RENTING. When it comes to outfitting your male attendants, you may find you're better off buying a suit rather than renting a tux. Keep an eye on department store sales or online deals, and your guys could snag a suit for an amazing price.

GO CASUAL. If you're having a super low-key backyard wedding, give your attendants the option of wearing something a bit more casual, such as khaki pants with white button-downs and bow ties, or simple sundresses in one of your wedding colors.

Photography, Music, Food, Cake, and More

EVEN IF YOU'RE WORKING with a small budget, you'll probably bring in professionals to help with at least some aspects of your big day. Try as you might, you most likely can't do it all yourself.

While there are certain things you may want to leave to the experts, there are also DIY options for many different elements of the wedding day. Sometimes you have to weigh what's most important: Your time or your money. When considering each of these wedding duties, decide if you can realistically tackle this task yourself or if you're better off outsourcing it.

In some cases, you might nix doing something yourself and instead enlist the help of an able and willing friend or family member in lieu of a seasoned pro. The questions and worksheets in this chapter will help you navigate the wedding vendor research and hiring process.

SAVVY TIPS

1. **KNOW WHOM TO BOOK EARLY.** Some vendors can perform only one wedding a day, such as photographers or videographers, so they're more likely to get booked further in advance. Make those major decisions early on in your planning process to ensure you get the one you really want.

2. **DON'T WASTE THEIR TIME (OR YOURS).** Try your best to get rate information from vendors before setting up meetings. There's no point in meeting with vendors in person only to find out you cannot afford their services. Prequalify those you want to meet with by weeding out any that are obviously out of your budget.

3. **ASK FOR RECOMMENDATIONS.** Ask your recently married friends for recommendations for different vendors for your wedding. You'll probably want to speak with friends who had a wedding of a similar style and budget to what you'll be working with.

4. **THINK OUTSIDE THE BOX.** Consider alternatives to traditional vendors and be open to newbies and amateurs if your budget is extra tight. You just might book the next wedding superstar at an amazing price! Just be sure to ask the right questions and cover all your bases to protect yourself in case of any funny business.

5. **GET EVERYTHING IN WRITING.** Every single vendor you hire or service you pay for in relation to your wedding should provide you with a contract that outlines all the duties or deliverables. You want to ensure that these contracts are solid and don't leave any open loopholes. Be sure to read the fine print, and don't be scared to ask for added verbiage to confirm times, a full list of deliverables, and the like.

DISCUSSION QUESTIONS

1. Do we have the budget to hire all professional vendors?

2. Do we have any talented family or friends we could ask to fill in for a professional?

3. Are any of these areas of the wedding of extremely low importance to us?

4. Are there certain aspects of the wedding we feel comfortable tackling ourselves?

5. Do we have any furniture or equipment that could be used in lieu of rental items?

Best Order to Book Your Vendors

1. VENUE
2. PHOTOGRAPHER
3. DAY-OF COORDINATOR
4. OFFICIANT
5. CATERER
6. MUSICIANS OR DJ
7. FLORIST
8. BAKER
9. RENTALS
10. TRANSPORTATION

PHOTOGRAPHY

When it comes to wedding vendors, photographers tend to top nearly every couple's list of priorities. At the end of your wedding day, the memories captured by your photographer will be precious to you. Your photos give you and your spouse visual reminders of the love and emotions associated with your day.

Choosing the right photographer at a budget you can afford can be a tough task. Photographers typically get booked up to a year or more in advance, so you'll want to start your search ASAP to give yourself the best chance of securing your top choice.

COMPARING PHOTOGRAPHERS

After doing some initial research, you'll want to meet with and interview potential photographers. Be sure to ask if they have your date available before meeting with them to prevent you both from wasting time. Use this space to record information about the photographers you are considering for your wedding, and compare the details to help guide your final decision.

	PHOTOGRAPHER 1	PHOTOGRAPHER 2	PHOTOGRAPHER 3
Studio Name			
Photographer Name			
Phone Number			
E-mail			
Website			
Hours of Coverage			
Other Inclusions			
Total Cost			
Additional Notes			

A Note on Videography

You may not have enough room in your budget to hire a professional videographer, but getting a recording of your big day is incredibly special. Video is something that tends to get pushed down the list because of the expense, but you don't have to pay a fortune to capture footage that will be priceless to the two of you.

If you don't own a video camera, consider borrowing one from a family member or friend. Designate someone to set it up on a tripod to film your ceremony and the exchanging of your vows. Even if this is the only footage you take of your wedding day, it will be worth the effort. You have no idea how meaningful it can be to relive those precious moments on your anniversary in the years to come!

MUST-ASK QUESTIONS

No matter if you're choosing a newbie photographer or a seasoned professional, you'll want to ask them some very important questions.

- Is photography your main business?
- How many weddings do you shoot a year?
- How many edited photos do you typically deliver from an average wedding?
- Have you shot a wedding at our venue before?
- Can we see a full set of proofs from a recent wedding?
- Are you willing to follow a shot list?

- How long after the wedding can we expect to see the photos?
- What does your package include? Do you offer à la carte pricing?
- What's your hourly rate?
- What amount of deposit is required to hold our date? When is the balance due?
- What forms of payment do you accept?
- Do you offer a referral program?

Ways to Save

FIND A NEWBIE. Consider hiring a photographer who is just getting started with weddings, whose pricing will likely be more affordable than someone who's been shooting weddings for a decade. Just make sure his or her style aligns with yours and that he or she has professional equipment and good-quality work.

ASK FOR À LA CARTE PRICES. Many wedding photographers package their services together in a bundle for a higher price. Typically, these packages could include engagement sessions, save-the-date photographs, or professionally composed albums after the big day. If you fall in love with a photographer's work but can't afford the full package, ask what it would cost for day-of coverage and high-resolution digital files. You can always order prints and your own photo album later.

PURCHASE SHORTER COVERAGE. Some photographers offer their coverage at a per-hour rate. If you want to bring the price down, ask if you can hire them for a shorter period of time. You might decide to have the photographer stay only through the major reception moments, like the first dance or cake cutting, to save some cash.

START YOUR SEARCH EARLY. Since so many photographers get booked up far in advance, starting your search early is a good idea. Not only will it give you a larger pool of potentials to choose from; it will likely save you money. Most photographers raise their prices each year, so booking in advance will get you next year's photography for this year's price!

ASK ABOUT REFERRAL PROGRAMS. Some photographers offer couples discounts or credits for referring new business their way. If you love your wedding photography, suggest your shutterbug to all your soon-to-be-married friends! You could possibly get yourself a free wedding album or prints to enjoy as a thank-you.

SELECTING A PHOTOGRAPHER

- ☐ **DO INITIAL RESEARCH:** Check out photographers online who service the area of your wedding venue.

- ☐ **CONFIRM PRICING:** If a photographer doesn't have prices listed on his or her website, request a rate sheet before scheduling a meeting.

- ☐ **BOOK A MEETING:** Once you've narrowed down a few potential candidates, meet with them to see if they "click" (pun intended) with you and your partner.

- ☐ **SIGN A CONTRACT:** Be sure to check your agreement for terms like coverage hours, cancellation fees, and ownership rights. Pay your deposit to hold your date.

- ☐ **SCHEDULE ENGAGEMENT PHOTOS:** An engagement session with your photographer will let you get a feel for his or her style.

- ☐ **CREATE A SHOT LIST (PAGE 110):** If there are specific photos outside the realm of normal wedding-day shots, be sure to give a list to your photographer so he or she is aware of your desires.

- ☐ **DISCUSS LOGISTICS AND TIMELINE:** Coordinate with your photographer about your wedding-day timeline and determine his or her arrival time and ending time to avoid overage charges.

- ☐ **PAY FINAL BALANCE:** Give your photographer payment for services so you can ensure that you've maintained your end of the agreement. You'll want to receive your proofs on time, after all!

THE WINNER

Studio Name: ..

Photographer Name: ..

Phone Number: ..

E-mail: ..

Website: ..

Package Details: ..

Total Cost: ..

Deposit Amount and Due Date: ..

Balance Amount and Due Date: ..

PHOTOGRAPHY, MUSIC, FOOD, CAKE, AND MORE

CREATING A SHOT LIST

Below is a list of common photos for weddings. Feel free to highlight shots you feel are must-haves or cross out any you don't care about. Use the blank space to add additional shot ideas or requests for your photographer.

FORMAL PORTRAITS

- ❏ Family Portraits
- ❏ Bride with Parents
- ❏ Bride with Grandparents
- ❏ Groom with Parents
- ❏ Groom with Grandparents

WEDDING PARTY PORTRAITS

- ❏ Bride with Her Attendants (group and individuals)
- ❏ Groom with His Attendants (group and individuals)

DETAIL SHOTS

- ❏ Attire Details
- ❏ Wedding Dress
- ❏ Bride's Accessories
- ❏ Bride's Shoes
- ❏ Groom's Shoes
- ❏ Groom's Accessories

CEREMONY DETAILS

- ❏ Bouquets
- ❏ Boutonnieres
- ❏ Ceremony Location Empty
- ❏ Ceremony Location Filled
- ❏ Flower Girl Outfit and Details
- ❏ Ring Bearer Outfit and Details

CEREMONY MOMENTS

- ❏ Processional
- ❏ Groom's Reaction to Seeing the Bride
- ❏ Exchange of Vows
- ❏ First Kiss
- ❏ Recessional

RECEPTION DETAILS

- ❏ Centerpieces
- ❏ Reception Space Empty
- ❏ Reception Space Filled
- ❏ Reception Details
- ❏ Photo Booth

RECEPTION MOMENTS

- ❏ Candid Reception Shots
- ❏ First Dance
- ❏ Parent or Loved-One Dances
- ❏ Speeches
- ❏ Cake Cutting
- ❏ Toasts
- ❏ The Grand Exit

MUSIC

Music tends to be a big part of a wedding and can really impact the atmosphere. Traditionally, couples would hire a live band, musicians, or a DJ to perform the tunes that create the soundtrack of their day. Luckily, there are great musical options for every price point, so you just have to choose the one that works best for you! Use this section to help determine the best option for your big day.

MUST-ASK QUESTIONS

If you opt to hire a professional, be sure to ask the following questions.

- Is this your primary business?
- How many weddings do you do in a year?
- Do you customize the music for each event?
- How do you handle song requests?
- Can we see a sample playlist?

- How do you hype up the crowd?
- What sort of equipment do you use? How much space will it take up?
- Have you worked at our venue before?
- What amount of deposit is required to hold our date? When is the balance due?
- What forms of payment do you accept?

CEREMONY MUSIC

Use the following chart to brainstorm songs for your wedding ceremony.

	PARTNER 1	PARTNER 2
Favorite Artists		
Favorite Songs		
Blacklisted Songs		
Do you prefer instrumentals or songs with lyrics?		
Processional Songs		
Recessional Songs		

RECEPTION MUSIC

BAND, DJ, OR PLAYLIST? Consider how you'll play music at your reception by first deciding if you'll have live music, hire a DJ, or hook up your own playlist. Unless you happen to be besties with some talented musicians who'd play your wedding as a favor, your budget might not allow for live music. Heck, you may not even be able to afford a DJ.

Music is definitely an area that you can tackle on your own with the right equipment and planning. If entertainment isn't high on your list of priorities, feel free to go the DIY DJ route.

How to Be a DIY DJ

1. CHOOSE A MUSIC PLATFORM: You could use Apple Music, Spotify, or another media player that plays music.

2. CREATE YOUR PLAYLIST: Add your desired songs and arrange them in the order you'd like to play them. Be sure to download them to your iPhone or media player using Wi-Fi so you won't use up your data on your big day or, if your wedding is in a remote location, you won't have to worry about getting service.

3. KEEP YOUR TIMELINE IN MIND: Schedule songs for key moments in your reception timeline by scheduling music by song duration.

4. BALANCE THE BEATS: Keep the music vibe appropriate for certain times in the reception. For example, don't play rowdy tunes during dinner.

5. GET THE RIGHT EQUIPMENT: You can run your playlist from your computer or an iPhone; you'll just need something to amplify the sound. It's a good idea to have a microphone for announcements and speeches as well.

6. DO A TEST RUN: Don't leave it till the day of the wedding to make sure your setup is solid. Visit your venue and do a test run prior to the big day. If you are using an iPhone, be sure to put it on airplane mode so phone calls and texts won't ring out over the sound system. Your songs are already downloaded, so no need to worry about not getting service.

BUILDING YOUR PLAYLIST

Whether you've got a professional running the show or you're hooking up your iPhone, you'll want to fill your playlist with a combination of upbeat, fun songs and loving, slow songs for dancing. Use the following chart to brainstorm some tunes for your wedding reception.

	PARTNER 1	PARTNER 2
Favorite Artists		
Favorite Songs		
Blacklisted Songs		
First Dance Song Suggestions		
Parent Dances		
Cake-Cutting Song		

FOOD AND DRINK

Food and beverage costs can take up a large chunk of your budget. Don't worry; this is expected at weddings. It's best to give your guests sustenance if your event will last more than four hours or occurs near or during a time when people eat, most likely lunch or dinner. You can make your budget work for you by being savvy about your food choices. Use this section to brainstorm your bites, compare the available options, and choose the one that's best for you!

DISCUSSION QUESTIONS

Ask yourselves the following questions to help guide your wedding catering choices.

1. What are our favorite foods?

2. Are there any dietary restrictions or allergies to consider?

3. What's more our style: sit-down, buffet, or passed apps?

4. How important is food in terms of our wedding values?

5. Are we comfortable doing any aspect of this on our own or with the help of family?

Ways to Save

CHOOSE INEXPENSIVE FOODS. Some items are less expensive than others, such as pasta. You can host a traditional-style meal for less by opting for foods that don't cost as much. Trust me, your guests will be intrigued and surprised if you go beyond the traditional steak, chicken, or fish options.

NONTRADITIONAL OPTIONS. These days, there are no rules about wedding food. Buck tradition and serve your favorite ethnic food instead, like Mexican or Thai.

SERVE LIGHT BITES. Can't afford to host a full sit-down meal? Serve light bites and appetizers. You can have them set out on buffet tables to save on service cost, too.

PRESENTATION IS KEY. You can make just about any food look fancy with the right presentation. Arrange your food in a nice display and no one will think twice about the cost.

BRUNCH, PLEASE! Breakfast foods, like eggs and baked goods, tend to be very affordable. You can serve a delicious brunch spread for much less than a steak dinner.

MOM-AND-POP SHOP. Consider hiring a local mom-and-pop restaurant to cater your big day instead of a traditional caterer. They often have more reasonable rates.

ASK THE PROFESSIONALS (FRIENDS AND FAMILY). If you are lucky enough to have a friend or family member who is a professional chef or works in the hospitality industry, don't be afraid to ask him or her for help and advice. This person might know a great restaurant that offers inexpensive options or be able to get you a better rate from his or her contacts in the industry.

CIY (CATER IT YOURSELF). If the professional route is out of your budget, cater your reception yourself or with the help of family and friends. Big batches of dishes like baked ziti or pulled pork are easy to prep ahead of time and would make for a great meal. If you have a friend who is a good cook, consider asking him or her for help.

POTLUCK PARTY! Create a true sense of community at your reception by asking your guests to bring a homemade side dish. You provide the main course and save on the extras. This works great for anyone who's hosting a wedding with a large guest list.

DESSERT ONLY. You could also plan your wedding for a time of day when a meal would no longer be expected. If you have a late ceremony, you could opt for a dessert-only reception.

MUST-ASK QUESTIONS

Caterers have to handle a decent amount of logistics. To make sure all your bases are covered, ask the companies you're interviewing the following questions.

- Are you licensed and insured?
- Have you worked an event at my venue?
- Do we need any permits, and if so, who handles them?
- Will there be service staff on-site to manage the meal?
- My budget for catering is $_____ for ____ people. What are my options in that range?
- What are your lowest-priced options?
- Do you have a preset menu, or can we create something custom?
- What service items and staff are included in the catering cost?
- Is there a corkage fee? Cake-cutting fee?
- Do you offer bartenders?
- Can I supply my own alcohol?
- What are your payment terms and accepted methods of payment?
- What is required to reserve our date?
- When is the final balance due?

COMPARING CATERING OPTIONS

Weigh the pros and cons of your catering options using this worksheet.

	CATERER 1	CATERER 2	CATERER 3
Company Name			
Primary Contact			
Phone Number			
E-mail			
Website			
Menu Options			
Cost per Head			
Total Cost			
Additional Notes			

CHOOSING A CATERER

- ☐ Think about the foods you'd like to serve at your wedding
- ☐ Do preliminary research on caterers in your area
- ☐ Call to get rough quotes for weddings with your guest count
- ☐ Schedule meetings with caterers who are a good fit, ask to sample food
- ☐ Get a firm idea of cost for the particular meal you're interested in
- ☐ Make your decision, sign a contract, and pay deposit
- ☐ Schedule a tasting if applicable
- ☐ Confirm delivery, setup, and breakdown times according to your timeline
- ☐ Pay final balance

THE WINNER

Record your caterer's info below.

Company Name:

Primary Contact:

Phone Number:

E-mail:

Website:

Package Details:

Total Cost:

Deposit Amount and Due Date:

Balance Amount and Due Date:

STOCKING THE BAR

Use this worksheet to determine what types of alcohol you want for your reception and how much of each you will need to purchase.

	OPTION 1	OPTION 2	OPTION 3
Beer			
Wine			
Liquor			
Mixers			

MENU

Use the chart below to record your wedding menu, including appetizers, main course, side dishes, bread, nonalcoholic beverages, alcohol, and desserts.

	OPTION 1	OPTION 2	OPTION 3
Appetizers			
Main Course			
Side Dishes			
Bread			
Nonalcoholic Beverages			
Alcohol			
Desserts			

PHOTOGRAPHY, MUSIC, FOOD, CAKE, AND MORE

CAKE OR OTHER SWEET TREATS

The wedding cake is a tradition at most events, but you don't have to limit your dessert options to cake. Dessert alternatives, such as cupcakes, donuts, cookies, and others, have been trending in the world of weddings. The wedding cake tends to be an attractive focal point and detail of the reception but can often be pricey due to elaborate decoration techniques.

 If you're on a budget, you may want to consider a more affordable option or think about getting your cake from a less expensive source than a fancy custom bakery. Use this section to weigh the various options and decide what desserts you plan to serve for your big day and where you plan to get them.

MUST-ASK QUESTIONS

If you're hiring a professional baker, it's important to get a full picture of the costs involved in creating your cake. Use this list of questions to get clarity on your cake expenses.

- What is your most popular cake design?
- What is the most affordable option in terms of flavors, icing type, and decoration?
- How are cakes priced: by the slice or by the size?
- What flavors do you offer?
- Are you licensed and insured?

- Is there an additional fee for delivery?
- Can you use my cake stand, or do you provide one?
- What are your accepted payment methods?
- What do I need to do to reserve my date?
- How much is the deposit?
- When is final payment due?

COMPARING SWEETS

Use the space below to record both your and your partner's favorite desserts and flavors from each category.

	PARTNER 1	PARTNER 2
Cake		
Cookies		
Doughnuts		
Pies		
Cobbler		
Cheesecake		
Absolute Favorite Dessert		

PHOTOGRAPHY, MUSIC, FOOD, CAKE, AND MORE

Ways to Save

RECRUIT A HOBBY BAKER. Have a friend or family member who makes absolutely amazing desserts? Consider asking him or her to make a special sweet something for your wedding day.

KEEP IT SIMPLE. Ornate decoration and frosting techniques will quickly drive your price up, so choose a simple design to save yourself some cash.

ADD YOUR OWN DECORATION. Have your baker frost your cake very simply and add your own decoration. A few fresh blooms can make a simple cake shine.

SERVE SHEET CAKE. Consider having a small cake on display for the traditional cake-cutting ritual, but serve your guests sheet cakes. They are much simpler to make and incredibly inexpensive.

NAKED CAKE. One hot trend has been to have a naked cake, or one that is minimally frosted with much of the cake exposed. Less decoration means less cost.

BUTTERCREAM DREAMS. Skip fancy fondant and opt for the more delicious (and less expensive) buttercream frosting. Your taste buds—and those of your guests—will thank you.

NORMAL FLAVORS. Rather than choosing a fancy or complicated cake flavor, opt for something simple, like a basic vanilla or chocolate.

SKIP THE CAKE! Instead of hiring a professional to create a stunning wedding cake, serve a variety of store-bought desserts instead. A spread of fruit pies would be lovely!

GROCERY GOODNESS. Consider purchasing your wedding cake from your local grocery store or big-box chain. Publix and Costco in particular are known for having affordable and delicious cakes.

ORDER A SMALLER CAKE. More often than not, the suggested size ends up being more than enough to accommodate your guest list. Opt for a smaller cake and supplement with other inexpensive desserts.

CHOOSING THE CAKE

- ☐ Gather inspiration for what you'd like your cake to look like
- ☐ Consider alternative dessert options
- ☐ Research baker options in the area and request quotes for cakes that accommodate your guest list size
- ☐ Schedule a meeting and tasting
- ☐ Discuss design details
- ☐ Make a decision, sign a contract, and pay deposit
- ☐ Confirm date and time of delivery or pickup if using rented cake stand
- ☐ Pay final balance

THE WINNER

Record your baker's info below.

Company Name: ...

Primary Contact: ...

Phone Number: ...

E-mail: ...

Website: ...

Design Description: ...

Total Cost: ...

Deposit Amount and Due Date:

...

Balance Amount and Due Date:

...

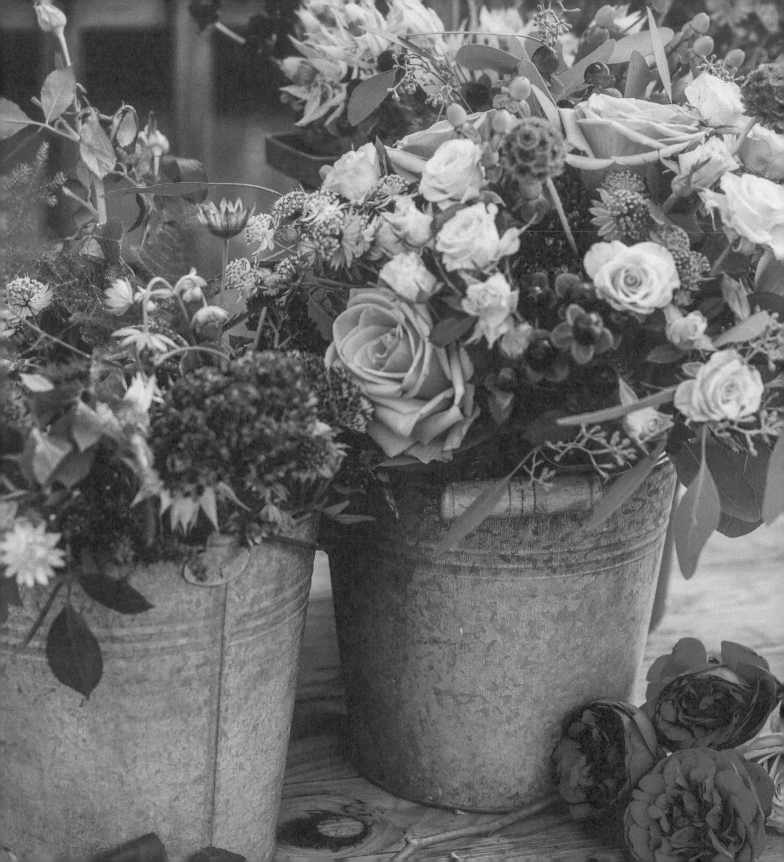

Decor, Rentals, Flowers, and Favors

WHILE PINTEREST MIGHT LEAD you to believe otherwise, how your wedding looks isn't really important in the grand scheme of things. However, if you want to stick to a certain aesthetic, you'll want to decorate your space in a way that fits your wedding theme. In the following pages, I'll share with you how to bring your wedding vision to life using decor, flowers, and other items.

SAVVY TIPS

1. CONSIDER FLOWER ALTERNATIVES. Fresh blooms can be costly. Try to come up with alternatives for decor so you can use fewer florals. There are so many creative ideas to suit any theme. Candles, vases, books, picture frames, and other items you already have in your home can be easily put together to make centerpieces and other decorative accents sans flowers.

2. RECYCLE (OR UPCYCLE). Chances are you toss a good amount of glass bottles and jars into the trash bin or recycling each week. Upcycle these items by giving them a fresh coat of spray paint. Metallic shades can add a glam look for very little investment. You can collect your bottles or jars over time and use them as vases or group them in bunches as a centerpiece.

3. REUSE THINGS YOU BUY. If it suits your wedding style, it suits your personal style, right? So, keep in mind that anything you purchase as decor for your big day could possibly be reused as decor in your home. Not only does it help justify the expenses, but you'll also have even more mementos around to remind you of your big day.

4. BORROW DECOR FROM FAMILY. Do your parents have a darling pair of covered chairs in a color that totally matches your wedding scheme? Incorporate them into your wedding decor by adding them as a fun seating area. Or borrow the crystal cake-cutting set from your Aunt Sally rather than buying one new. You'll cut your costs by getting things on loan.

5. GO WITH FAUX FLOWERS. Get the floral look for less by creating your own fake blooms out of paper or fabric. You could also consider purchasing silk flowers from your favorite hobby or craft store. The great thing about faux flowers is you can resell them to another bride or use them again after the wedding.

DISCUSSION QUESTIONS

1. What items do we realistically have the skills to DIY?

2. Do we have any furniture, equipment, or other objects that could be used in lieu of rental items?

3. Do we have the time to devote to crafting decor projects?

4. Do we feel comfortable tackling flowers ourselves?

5. Do we have the supplies and tools needed to create the projects we want to take on?

6. Do we have skilled friends or family who could help us get crafty?

7. Would it be better to rent things or buy them?

8. What can we buy that could be repurposed or resold after the big day?

9. What can we borrow from family and friends to incorporate into our decor?

A Note about DIY

While creating DIY projects can be a wonderful way to add personal touches to your wedding day, they don't always save you money. Keep these tips in mind when considering taking on a DIY wedding project:

BE SMART AND SAVVY! For each potential DIY project, make sure to weigh the cost of the supplies and tools as well as your time. You may find that you're better off buying something or paying someone to create it for you.

HAVE REALISTIC EXPECTATIONS. Some wedding blogs and websites tout their featured weddings as "DIY," while in reality they were handcrafted by a team of seasoned professionals.

KNOW YOUR OWN LIMITATIONS. Get real with yourself about your abilities, skills, and time. Don't bite off more than you can chew or take on projects that are outside your comfort zone. Now is not the time to become a welder if you've never used a blowtorch.

GIVE YOURSELF AMPLE TIME. Don't wait until the last minute to start your projects. Ideally, you should aim to have your DIY projects completed two weeks before the wedding day to avoid last-minute stress and frenzy.

SAVE ON SUPPLIES. Just like with all other aspects of your wedding, make sure to shop savvy! Head to your local craft store armed with coupons and take advantage of sales to get the best price on tools and supplies.

EVENT DESIGN AND SETUP

Use the space below to make sketches or paste in a mockup of your ceremony and reception spaces. Feel free to use and update the sketches with placements for items such as tables and chairs, flower arrangements, the dance floor, and more. This will help give you a clearer picture of all the items needed to pull your event together, whether renting, purchasing, or making them yourself!

DECOR INSPIRATION

When it comes to wedding decor, you don't have to spend a fortune to create a beautiful event. Check out the inexpensive supplies and ideas below for inspiration.

TRASH TO TREASURE

Wine corks	Books	Old sheets	Maps
Old fabric	Paint chips	Coffee filters	

RAID THE RECYCLING BIN

Food jars	Tin cans	Paper	Cardboard boxes
Wine bottles	Newspaper	Bottle caps	

FREE AND NATURAL ELEMENTS

Tree branches	Pinecones	Leaves	Rocks

INEXPENSIVE CRAFT SUPPLIES

Craft paper	Rope	Spray paint	Ribbon
Crepe paper	Twine	Wrapping paper	
Buttons	Yarn		

THRIFT STORE FINDS

Vases or jars—great for candy buffets or centerpieces

Patterned sheets—perfect for tearing and making garlands, streamers, or photo booth backdrops

IDEAS FOR PAPER

Use a punch shape to make confetti

Make a garland

Use in your invitations or programs

Wrap around a can or vase for color and texture

Create a table runner

Make paper flowers

Craft a photo backdrop

Glue a shape to a toothpick for a cupcake topper

Make custom envelope liners out of maps or wrapping paper

IDEAS FOR VESSELS

Use as vases

Spray-paint to match your wedding colors

Fill them with twinkle lights

Etch glass bottles or jars

Wrap cans in fabric or paper

Turn old wine bottles into table numbers

Continued

Keeping your wedding vision and theme in mind, brainstorm some decorative accents and details for your day. Use the space below to write out some of your ideas.

RENTALS

Unless you chose an all-inclusive venue, you'll likely need to order some rental items to bring your wedding plans to life. Whether you just need tables and chairs or a full tent with a dance floor and more, renting items for your big day takes some planning and logistics. This section will help you outline which rental items you need and give you space to record all the details.

Choosing Your Rentals

Before you book, you'll want to take the time to map out your venue and make a plan. Get a floor plan of both ceremony and reception sites so you can sketch in placement for all the major items. See the list of possible rentals below for help, and feel free to write in the number of tables, chairs and other elements you need.

CEREMONY RENTALS

Chairs ..

Pews ..

Arbor or Archway

Columns ...

Aisle Runner ..

Aisle Decor ...

RECEPTION RENTALS

TABLEWARE

Linens ..

Dishes ..

Flatware ...

Glassware ...

Napkins ..

FURNITURE

Chairs ..

Tables ..

Buffet and Food Service Tables

Lounge Furniture

Bar ...

OTHER

Chair Covers ...

Lighting ...

Dance Floor ..

Tent ..

COMPARING RENTAL COMPANIES

If you are renting a venue for your event, ask the venue manager if there are any preferred rental companies that he or she works with as a starting point. If not, search the Web for rental companies in your area. It's best if you consult with at least a few so you can compare pricing and choose the ideal option. Don't forget to consider online rental options, such as RentMyWedding.com, which offer convenient two-way shipping for many popular wedding rental items.

Consider all the items you'd like to have included in your day, and ask each company for a quote for the exact same list of items. You don't have to end up renting the entire list of items if it comes in over budget, but it will give you a baseline for a more accurate comparison.

List the items you want to request a quote for below.

ITEM	QUANTITY NEEDED

Use the following chart to record the information and quotes you receive from different rental companies.

	COMPANY 1	COMPANY 2	COMPANY 3
Company Name			
Primary Contact			
Phone Number			
E-mail			
Website			
Any Omissions			
Delivery and Setup Fees			
Total Cost			
Additional Notes			

Use this information to make a final decision about your choice of rental provider.

MUST-ASK QUESTIONS

When requesting a quote from a rental company, be sure to ask the following questions.

- How early do you make a delivery on the day-of?

- Does the rental fee include setup and breakdown, or is that an additional charge?
- Are there additional fees for delivery or distance?
- When do we need to give final rental numbers to you?

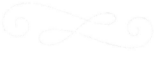

Miscellaneous Decor Details

Don't forget about these small details for your big day:

- Ring Pillow
- Cake Topper
- Card Box
- Cake Server

- Champagne Flutes
- Flower Girl Basket
- Something Old, New, Borrowed, Blue

Ways to Save

KEEP IT SIMPLE. When you're working with a tight budget, you likely won't have the funds for fancy pipe-and-drape systems or luxurious lighting. Keep your rental plans simple and focus your efforts on elements that enhance the guest experience.

READ THE FINE PRINT. Make sure you check your rental agreements for fees or penalties. Some rental companies charge separately for setup and breakdown or charge a late fee if the items aren't properly prepared for pickup at the designated time. Be sure to make note of those policies to avoid extra charges.

UTILIZE YOUR VENUE'S OPTIONS. If you book a venue that has basic rentals included, use them! Is it really worth paying extra to bring in a certain type of chair? Are fancy linens really that important in the grand scheme of things? Instead, focus on ways to enhance what you've already got to work with.

CHECK WITH YOUR CATERER. Be sure to ask your caterer what rental items are included in your service package, such as chafing dishes, cake stands, beverage dispensers, platters, and the like.

LET YOUR CHAIRS PULL DOUBLE DUTY. If your ceremony and reception are in the same venue but you have to bring in your own rentals, consider ordering just one set of chairs and having them moved during the cocktail hour. You'll cut your chair spending in half!

FINAL RENTAL SELECTIONS AND DETAILS

Use this space to record your final rental order, cost, details, and vendor information for easy reference.

COMPANY	PRIMARY CONTACT	PHONE NUMBER	E-MAIL	WEBSITE	DEPOSIT AMOUNT AND DUE DATE	BALANCE AMOUNT AND DUE DATE

DELIVERY DATE	DELIVERY TIME	PICKUP DATE	PICKUP TIME

ITEM	QUANTITY ORDERED	PRICE PER ITEM

FLOWERS AND FAVORS

Flowers are one of the most beautiful details of a wedding day but can also be one of the most expensive. While not a requirement, they do help make the day look and feel a bit more special. Luckily, there are many ways to incorporate fresh flowers into your celebration without breaking the bank.

From finding alternatives to supplementing with greenery or fillers, there are ways to stretch your floral budget so you can still have that lovely look. This section will help you decide where to use fresh florals and where to consider other decor options. You'll also get tips on tackling this wedding task yourself if you're up to the challenge!

After several worksheets and checklists designed to help you make a budget-friendly flower plan, this chapter wraps up with some simple resources to choose your wedding favors—if you decide to give your guests a little something to bring home with them.

MUST-ASK QUESTIONS

If you choose to hire a pro to arrange your flowers for your big day, be sure to ask the following questions.

- My budget is $_____. What can you do within that range?
- What flowers are in season during the month of my wedding?
- My wedding vision or theme is _____. What flowers do you suggest?
- My color palette is _____. What flowers are available in my budget in that color?

- How long have you been doing weddings?
- How many weddings do you take on in a single day?
- How would you describe your style?
- Do you make up mock-ups or samples prior to the big day?
- How is your pricing structured?
- Is there a delivery fee?
- What amount of deposit is required to hold our date? When is the balance due?
- What forms of payment do you accept?

FLOWER INSPIRATION

Use the space below to brainstorm ideas for each of the following floral arrangements for your wedding. Feel free to print and paste inspirational images to accompany your ideas.

ITEM	DESCRIPTION	PHOTO INSPIRATION
BOUQUETS		
Bride		
Bridesmaids		
Flower Girl		
CORSAGES		
Mother of the Bride		
Mother of the Groom		
Other		
BOUTONNIERES		
Groom		
Groomsmen		
Father of the Bride		
Father of the Groom		
Ring Bearer		
Other		
CEREMONY FLOWERS		
RECEPTION FLOWERS		
Table Arrangements		
Other Reception Flowers		

Ways to Save

CHOOSE FLOWERS THAT ARE IN SEASON. Picking flowers that are in season means they are more readily available and will likely be more affordable. For a list of in-season flowers, refer to the In-Season Flowers section on page 142.

SHOP LOCAL. Visit your local farmers' market and purchase your flowers yourself. You'll get to pick the freshest and best-looking buds, and you'll feel good knowing that you are supporting a local business.

CHOOSE LOW-COST VARIETIES. Some types of flowers are just more expensive than others, typically because they are harder to source and are therefore rarer. Opt for inexpensive options that come in a myriad of colors, such as carnations, daisies, roses, and chrysanthemums.

EMBRACE FILLER FLOWERS. Fill out your floral arrangements with low-cost filler flowers. Utilizing baby's breath, wax flowers, thistles, rice flowers, or Queen Anne's lace can really help to bulk up your arrangements without adding much cost.

MULTIPURPOSE ARRANGEMENTS. Why double up on your floral order when you can have some of your arrangements pull double duty? Instead of paying for extra reception centerpieces, place empty vases on the head table so you and your bridesmaids can repurpose your bouquets into table decor.

CONSIDER NONFLORAL DECOR. If money is a big issue, you might consider skipping fresh florals completely or just cutting back on the places you're using them. You could always craft paper flowers instead of using real blooms, allowing you to get that floral effect for less.

GO WITH GREENERY. If you're going for an organic vibe, you might choose to use mostly greenery in your arrangements with limited actual flowers. Greens like eucalyptus, Italian Ruscus, ferns, and others are wonderful to work with and add gorgeous color with lower expense.

BUY IN BULK. Instead of purchasing smaller quantities from a grocery store or similar, head to a flower market or order from a florist who can supply you with flowers in bulk. This can save you significantly on your overall floral spend.

ORDER FLOWERS ONLINE. Discover the convenience of online floral wholesalers. Check out popular sites like BloomsByTheBox.com to order wedding-worthy flowers in bulk at great prices.

DARE TO DIY. Don't be scared to tackle your flowers yourself or with the aid of some trusted helpers. Explore online tutorials and resources to educate yourself on arranging your own wedding flowers. It's totally doable, especially if you're keeping things relatively simple.

SO, YOU WANT TO DIY YOUR WEDDING FLOWERS?

Doing your own flowers doesn't have to be intimidating. Follow these simple steps to create your wedding-day floral plan:

1. MAP OUT YOUR FLORAL ARRANGEMENTS. Using the floor plan from your venue, sketch in any locations that you want to place flower arrangements. Then create a list of all the arrangements that you'll need.

2. GATHER INSPIRATION. Visit Pinterest, and focus on styles that fit your wedding theme, vision, and color palette. Make note of which types of flowers you're drawn to, and check to see if they are in season during the month of your wedding.

3. STICK WITH A FEW KEY BLOOMS. Focus on choosing three blooms. Select a large bloom to serve as the focal flower and two smaller flowers as accents. Then fill in the rest with greenery or filler flowers.

4. CREATE A RECIPE. Using your floral ingredients as determined in the previous tip, create recipes for each of your wedding arrangements to determine how many of each bloom type you'll need.

5. ADD UP YOUR TOTALS. After you've created your floral recipes, it's time to tally the number of each flower you'll need. Add up all the stems from your various arrangements to figure out your total floral order.

6. COMPARE FLORAL SUPPLIERS. Visit websites or local flower markets to research pricing for the floral types you decide to use in your arrangements. Let that information help you decide where to place your flower order.

7. ORDER YOUR FLOWERS. Once you've decided where to buy your blooms, it's time to place your order. Choose a delivery date of two days before your wedding to give your blooms enough time to rehydrate before arranging.

8. GET NECESSARY SUPPLIES. Make sure you have all the supplies you'll need to craft your arrangements so you can get to work when the flowers arrive. Order supplies online or pick them up locally. Don't forget to use a coupon!

9. PREP THE FLOWERS. Unpack and hydrate your flowers as soon as possible in warm water upon receiving them. Remove all thorns and leaves from the bottoms of the stems. Leaves can contaminate the water and cause your blooms to wilt more quickly. Trim your stems at a 45-degree angle, and do so underwater if possible to avoid air bubbles.

10. ARRANGE AND TRANSPORT. Once your blooms are hydrated, you can start arranging! If you arrange your flowers in a location other than your venue, you must carefully transport them to your wedding site.

DIY FLOWER SUPPLY LIST:

- ☐ Floral Scissors
- ☐ Paring Knife
- ☐ Floral Wire
- ☐ Flower Food Powder
- ☐ Floral Tape

- ☐ Straight Pins
- ☐ Ribbon
- ☐ Floral Foam
- ☐ Buckets
- ☐ Cool Room for Storage

In-Season Flowers

Choosing flowers that are in season during the month of your wedding can save you a significant amount of money. Here's a handy list of the most seasonally available and affordable blooms to choose from.

WINTER

alstroemeria, amaryllis, carnation, chrysanthemum, evergreens, gerbera daisy, ginger, holly berry, lily, narcissus, orchid, pansy, protea, Queen Anne's lace, rose

SPRING

amaryllis, anemone, apple blossom, bird of paradise, calla lily, cherry blossom, cornflower, dahlia, delphinium, freesia, gardenia, hyacinth, lilac, lisianthus, orchid, peony, protea, ranunculus, rose, seeded eucalyptus, stephanotis, stock, sweet pea, tulip, wax flower, zinnia

SUMMER

alstroemeria, amaranthus, baby's breath, bird of paradise, calla lily, carnation, chrysanthemum, cockscomb, dahlia, delphinium, dianthus, freesia, gardenia, genista, gladiolus, hydrangea, hypericum, iris, lilac, lisianthus, Stargazer lily

FALL

alstroemeria, anemone, baby's breath, carnation, chrysanthemum, cockscomb, freesia, gerbera daisy, gladiolus, hypericum, iris, juniper, lily, orchid, protea, Queen Anne's lace, rose, sunflower, zinnia

MAKING FLOWER SELECTIONS

Brainstorm some possible flower choices using the following chart. Come up with three different ingredient lists to consider for your floral needs. You can then use this list to craft the recipes for each type of arrangement.

	OPTION 1	OPTION 2	OPTION 3
Focal Flower			
Second Flower			
Tertiary Flower			
Fillers			
Greenery			

The Winners

Focal Flower	
Secondary Flower	
Tertiary Flower	
Fillers	
Greenery	
	Flowers Needed (Recipe)
Bride Bouquet	
Bridesmaids Bouquets	
Groom Boutonniere	
Groomsmen Boutonnieres	
	Flowers Needed (Recipe)
Centerpieces	
Reception Flowers	

CHOOSING YOUR FAVORS

Wedding favors are one of the items that tend to get cut from the list, especially when the budget is tight. It's always nice to offer your guests a small token of appreciation, and the truth is favors don't have to cost much money.

Trinkets and tchotchkes typically get tossed in the trash, so instead, opt for something edible. Whether you offer some freshly popped popcorn or one of your grandmother's signature cookies, your guests are sure to enjoy a treat.

YOUR BUDGET: Do you have the funds to purchase or make wedding favors?

YOUR VISION: Your favors should reflect the vibe and style of the rest of your wedding details.

YOUR VALUES: Consider supporting charities or causes you're passionate about in lieu of a trinket.

YOUR TIME AND ENERGY: If you're already tackling a ton of other DIY projects, you might want to buy premade favors.

Consider the different aspects of a wedding favor that are important to you and use them to guide your decision. Check out the following examples to get the ideas flowing, whether premade or DIY:

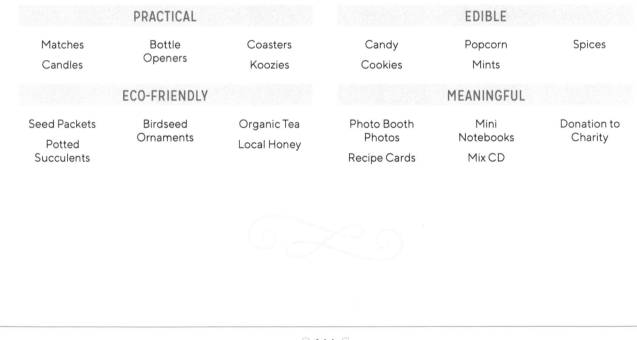

PRACTICAL

Matches	Bottle	Coasters
Candles	Openers	Koozies

EDIBLE

Candy	Popcorn	Spices
Cookies	Mints	

ECO-FRIENDLY

Seed Packets	Birdseed	Organic Tea
Potted	Ornaments	Local Honey
Succulents		

MEANINGFUL

Photo Booth	Mini	Donation to
Photos	Notebooks	Charity
Recipe Cards	Mix CD	

Ways to Save

CHECK FOR DISCOUNTS. Click your way to TheBudgetSavvyBride.com for weekly wedding deals and sweet discounts on everything from favors to flowers, attire, and more!

MAKE THEM YOURSELF. Prefer not to buy your wedding favors? Consider making them yourself! Whether that's crafting s'mores kits or birdseed ornaments, DIY could save you money and add a more personal touch.

KEEP IT SIMPLE. Don't worry about giving something lavish. Keep your wedding favors simple and savvy. There are tons of ideas you can create or buy for less than a few bucks each.

SWEET TREATS. Giving something edible is always a good idea. There is such a wide variety of sweets to choose from. Pick a treat that you and your partner love as an added infusion of your personalities.

A GIFT THAT KEEPS GIVING. Having an eco-friendly wedding? Go green and present your guests with a gift that keeps on giving: seeds for a lovely flowering plant or herb.

MAKE IT SEASONAL. Having a winter wedding? Give your guests some cocoa mix or tea bags so they can sip something warm and delightful after the reception is over. Fall wedding? Whip up some pumpkin spice trail mix!

GO EASY ON THE PACKAGING. Don't feel the need to go overboard creating a fancy package for your wedding favor. There are plenty of chic and stylish bags and boxes to choose from. Add a sticker and you're good to go.

MAKE YOUR FAVOR DISPLAY A FOCAL POINT. Use your wedding favors as a chance to add another unique visual detail at your reception. Create a colorful candy buffet that your guests can help themselves to, or stack piles of boxes containing sweet treats atop a table for a unique focal point.

FAVORS PULL DOUBLE DUTY. Have your wedding favors pull double duty by also acting as escort cards or place settings at your reception. Create custom tags to attach to your favors with guests' names and table numbers. Two birds, one stone!

CHOOSE SOMETHING PRACTICAL. You can never go wrong with something they'll actually use. Matches, Koozies, bottle openers, coasters, fans, luggage tags, and the like all make thoughtful and practical favors for your wedding.

The Other Parties

A CHALLENGING TRUTH ABOUT planning a wedding is that you're actually planning a number of different events rather than just one. From marking your acceptance of a proposal with an engagement party all the way through the day-after brunch, there may be a half-dozen celebrations or more to accompany the main event. While none of these extra parties are a requirement, nor are they all something you will have to pay for, they do warrant a dedicated chapter that shares ways to plan these events in a savvy manner.

There are not only etiquette topics to keep in mind but also budgetary considerations for these pre-wedding events. Use this chapter to help navigate the waters of planning your auxiliary wedding events.

SAVVY TIPS

1. DON'T COMMIT AN INVITE FAUX PAS. It's bad form to invite someone to your engagement party or bridal shower if you're not planning to invite him or her to your actual wedding. If you imagine your guest list is going to be a major challenge, keep your pre-wedding events to only your very closest friends and relatives in order to avoid any awkward situations. And an added bonus: Your hosts will probably save money by entertaining fewer people.

2. MAKE SURE YOU'RE REGISTERED. Although you might not expect or ask people to bring a gift to an engagement party, there are plenty of people who will show up with something to offer you. Having even a small registry set up ahead of time would be a good idea to assist your guests in picking something you'll both love.

3. BE GRACIOUS. Be sure to take the time to thank your event hosts as well as anyone who attends your pre-wedding celebrations or sends you a gift of congratulations. Snag some stationery and stay on top of your thank-you note writing. Pick up some generic thank-you cards at your local big-box store and save any personalized stationery orders until after the wedding day.

4. MAKE YOUR PREFERENCES CLEAR. In most cases you won't be the one planning these pre-wedding festivities. Your family or friends will be stepping in to throw you an engagement party, bridal shower, bachelor or bachelorette party, or rehearsal dinner. Be sure to let your hosts know about your tastes and preferences for these different events so they can plan the best party for you!

5. THINK OUTSIDE THE BOX. Don't feel stuck inside the confines of tradition when it comes to pre-wedding events. You don't have to have a wild night out for a bachelorette party or a stuffy luncheon for a bridal shower. Consider alternatives, like doing a group activity, outing, or experience, rather than the typical options for these events.

ENGAGEMENT PARTY

Engagement parties are a fun way to celebrate your newly engaged status with those nearest and dearest to you, but they are in no way a requirement of wedding planning. If your families or friends don't offer to throw you a party, don't feel obligated to host something yourselves, unless you really want to.

Beyond the Basics

Consider these engagement party ideas if you want to save money.

- **HOST A BACKYARD BARBECUE:** Instead of renting a venue and paying for catering, host a backyard barbecue at the home of a family member or friend.
- **MEET UP WITH FRIENDS AT YOUR FAVORITE BAR:** Keep things super casual and round up your closest pals to have a celebratory drink at your local watering hole.
- **ARRANGE A DINNER WITH THE FAMILIES:** If you don't want a big to-do, consider planning an intimate dinner with just the families to formally celebrate the engagement.
- **PLAN A POTLUCK:** Invite your loved ones over and host a potluck. Every guest can bring a dish they love for a budget-savvy meal.
- **MAKE IT A BRUNCH EVENT:** Instead of hosting an evening celebration, opt for a Sunday brunch instead. Host it at home or in a private room at a restaurant.

Engagement Party Tips

- **DON'T RUSH IT:** Give yourself time to think about your wedding plans before having an engagement party. You don't want to invite someone to celebrate the proposal who ends up getting nixed from the guest list for the main event! If you do have a party soon after popping the question, keep it to just close family and potential bridal party members.
- **MEET AND GREET:** Use your engagement party as an opportunity to introduce family members and friends to one another.
- **DIY DECORATIONS:** There's no need to get overly fancy with the decor for an engagement party. Just enjoy the company of your family and friends.
- **APPS AND DRINKS:** Have a cocktail-style engagement party to keep costs in check. Finger foods and some cheap bubbly are all you need for a good time.
- **CASUAL INVITES:** Use online invite options, like PaperlessPost.com, to spread the word about your engagement party, rather than mailing printed invitations.

BACHELOR AND BACHELORETTE PARTIES

It's tradition for the bridal party to host bashes for the couple to celebrate their last days of being single, and they typically foot the bill for the guests of honor. Your bachelor or bachelorette party should fall in line with the rest of your wedding plans and be an accurate reflection of your personality, style, and values.

- **MAKE A YES-AND-NO LIST:** If you're not into all the typical debauchery associated with bachelor and bachelorette parties, feel free to let your host know your preferences. Give them a list of what you're cool with and what gets a definite NO from you.
- **KEEP THINGS SIMPLE:** If you are on a budget for your wedding day, you may not want to travel far for your bachelor or bachelorette party because of the added expense. Let your host know your desires to keep the party local for budgetary reasons if necessary.
- **GO AGAINST THE GRAIN:** Instead of the typical bar crawl, consider doing a fun activity together. Take a paint-and-wine class, go to a wine tasting, or go see a concert together. It can be whatever you want!
- **VIPS ONLY:** You may feel tempted to invite all your various pals, but it's best to limit your guest list to your bridal party and absolute closest friends. Keeping things small not only helps keep costs in check but also makes things simpler to coordinate.
- **HAVE FUN:** Be sure to enjoy yourself and have a good time with your friends. Don't forget to give your hosts and planners a special token of your thanks for planning a great party for you!

BRIDAL SHOWER

The bridal shower is typically thrown by the bride's best girlfriends or some close family members. Bridal showers can vary in formality and style, but the sentiment is the same: to shower the bride with love, gifts, and even some advice for her upcoming marriage. Give your hosts an idea of the style and vibe you are comfortable with so they can plan an event that suits you. Whether you take a hand in the planning or simply show up to the party, this event is all for you, so be sure to enjoy it. Here are some things to consider:

- **GIVE DATE OPTIONS:** Consider giving your shower hosts a few potential dates that work for you and letting them choose the date that best fits their schedule.
- **KEEP TRACK OF GIFTS:** Have someone record a list of the gifts you receive as well as the names of the gift givers so you can easily write thank-you notes.
- **SHOWER GAMES:** You may or may not want to have traditional or cheesy games at your

bridal shower. Feel free to let your hosts know your preferences in this area.

- **FAVORS:** You may want to chip in on favors for all the guests who attend your shower. A sweet treat is a great way to say thanks for celebrating with me!

- **DRESS THE PART:** You don't need to buy a whole new outfit for your bridal shower, but you'll want to wear something you feel good in, since photos will likely be taken.

- **DON'T FORGET THE HOST GIFT:** Be sure to thank your hosts with a proper, thoughtful gift. Hosting and planning an event is tough work, and they did it all for you!

REHEARSAL DINNER

Your rehearsal dinner will follow the wedding rehearsal the night before the wedding. You may or may not be paying for your own rehearsal dinner, as typically one of the partners' families tends to cover this expense. Here are some things to factor in as you make your plans for this event.

- **WHO'S HOSTING AND PAYING?** It has been tradition for the groom's parents to host the rehearsal dinner, since the bride's family usually pays for the wedding. That may not necessarily be the case for you, so be sure to clear this up when discussing budget and contributions with your families.

- **SET THE GUEST LIST:** Anyone who has a role in the wedding should be invited to the rehearsal dinner. Each member of the wedding party should get a plus-one to the dinner. Couples also usually include their parents, grandparents, and any additional family members at the discretion of the budget. Depending on the money you're working with, you may or may not want to also invite all out-of-town guests.

- **STYLE:** Your rehearsal dinner could be as fancy or as casual as you'd like, based on your guest list and budget for this pre-wedding event. The style can complement but shouldn't overshadow the wedding itself.

- **FIND A SPOT:** Choose a location that makes things simple and affordable while giving you a chance to eat a nice meal and spend more time with your closest loved ones. Restaurants are a popular choice because they don't require much decorating or fuss. Choosing something that highlights the local flavor is always a nice idea.

- **SWITCH IT UP:** Don't go for the same food or ambiance as the wedding. You don't want to serve the same stuff to your guests two nights in a row. Choose a unique menu that is distinctly different from what you are serving for the wedding meal.

DAY-AFTER BRUNCH

A day-after breakfast or brunch isn't necessarily expected but can be a nice way to extend the time you spend with your loved ones during the wedding weekend. Often, the couple or one of their sets of parents will host a casual gathering the morning following the wedding. The wedding day often goes by in a flash, so this extra time is sometimes the best chance to really connect with some of your guests. It's also a great opportunity for out-of-town guests to drop in and say good-bye before traveling home. If the majority of your guests are coming from out of town and staying in the same hotel, you may opt to gather there. If the hotel offers a continental breakfast, you won't have to worry about preparing or paying for a catered brunch, and you'll still have the opportunity to spend more time with your nearest and dearest. If this is not the case, you can plan for this post-wedding gathering by asking the following questions.

- **WHO'S HOSTING AND PAYING?** Unless you really want to host this event yourself, don't feel obligated to have the day-after brunch at your own home. Decide if your or your partner's parents are going to host this gathering and if they plan to cover the treats.

- **WHO'S INVITED?** Generally speaking, everyone who was invited to the wedding is typically included in the day-after festivities. Since this event tends to be casual, it's not as much of a fuss to host everyone.

- **WHERE WILL WE HAVE IT?** If your or your family's home isn't equipped for a large group, consider finding a no-cost neutral location, like a public park, to meet up. Remember, this is a laid-back meet-up to spend more time with your loved ones.

- **WHAT WILL WE SERVE?** Brunch is such an easy meal to cater for, which makes this event low stress. Pick up a few dozen bagels or donuts, or bake some breakfast casseroles for your guests to enjoy while they mingle and say their farewells.

Ways to Save

LOCATION FOR LESS. Hosting your pre-wedding events at the home of a family member or friend will likely cut back on expenses. You could also consider a no-cost neutral location, such as a public park.

KEEP IT INTIMATE. Just like with any event, the fewer people you invite, the less expensive it will be. Keep your guest list tight to ensure a doable budget.

BYOB. Hosting an event at a venue that will allow you to supply your own alcohol could save you hundreds of dollars.

DON'T FEEL OBLIGATED. If you don't want to have an engagement party, shower, or day-after brunch, don't feel like you absolutely have to. Remember, this is your wedding.

KEEP IT SIMPLE. If budget is a tough topic for you or your hosts, encourage them to adhere to the same values you're applying to your big day. Be practical and down-to-earth with financial decisions for each of these parties, especially if you're contributing monetarily. Keep your focus on the main event!

Accommodations, Transportation, and More

ONCE THE MAJOR DETAILS are in place for your wedding day, there are some other logistics you'll need to organize, like hotel room block reservations and group transportation. Since you're working with a limited budget, you may not be spending as much money or time on these details, but they are still important since they could affect your guests. This chapter will help you organize your wedding logistics, from where you'll stay on your wedding night to how you'll get to and from the celebration.

SAVVY TIPS

1. GET YOUR GUESTS THE BEST PRICE. You want to get the best deals on everything for your wedding, right? Well, make sure you do the same thing for your guests. Use sites like Skipper (HiSkipper.com) to find and reserve room blocks at the best prices possible. It's completely free and saves you time and money by doing the research for you.

2. LOCATION, LOCATION, LOCATION. If at all possible, choose a hotel that's convenient to your wedding location. You don't want to have to list long, complicated directions or anything that could potentially confuse your guests.

3. OFFER MULTIPLE OPTIONS. If you have guests who are in two different camps when it comes to hotels and accommodations, consider offering them two different hotel room block options. It might be best to share both a low-cost option and a more midpriced option. This allows your guests to choose the one that works best for them.

4. CHECK THE POLICIES. Be sure to check with each hotel about its room block policies. Some establishments require a deposit to hold a certain number of rooms—you could end up stuck paying for any unreserved rooms. Read the fine print and ask each hotel for their specific policies.

5. ASK ABOUT PERKS. Some hotels will offer a free room for the bride and groom on the wedding night after a certain number of rooms are secured for your room block. Check with each hotel to see if it offers any perks for couples who are getting a room block for their wedding weekend.

6. DON'T FORGET TO INFORM YOUR GUESTS. It's important to share any info about room blocks or shuttles with your guests to make things more convenient for them. Add these details to your wedding website so that your guests know what their options are.

ACCOMMODATIONS

The Couple

If you're getting married in the same city you live in, you may choose to spend the night before the wedding in your own home. If you and your partner live together and want to have the "magic" of seeing each other for the first time at your ceremony, one of you may opt to stay with a friend or consider booking a hotel for the night.

The Wedding Party

Are the members of your wedding party local to your venue location, or will they be traveling from out of town? Make sure you get the information from any attendants who are staying in hotels. Maybe you'll want to have a slumber party with your attendants the night before the wedding.

Family and Out-of-Town Guests

If a large number of your guests will be traveling from out of town to attend your wedding, you may want to consider reserving a room block at a nearby hotel. You want to ensure that your loved ones are not left out of your celebration due to not having a place to stay. This is also a nice idea because it encourages your friends and loved ones to all stay at the same hotel, making it easier to mingle and coordinate with other guests. It can be helpful logistically if you're hiring transportation to shuttle guests from the hotel to the wedding space as well, as the room-blocked hotel can be designated as the pickup and drop-off spot.

Room blocks are more necessary if your wedding is taking place over a holiday weekend; during a large festival, conference, or sporting event; or happening in a town with limited accommodation options. The best time to book a room block is dependent upon the length of your engagement, but generally speaking, the sooner the better. Each hotel might offer different types of room blocks depending on its policies. Especially for couples on a budget, you'll want to avoid any hotels that require the couple to pay a deposit to guarantee a certain number of rooms filled. Do your best to find a hotel that offers "courtesy blocks" so you don't have to pay for any unsold rooms.

MUST-ASK QUESTIONS

When considering hotels for your wedding guests, there are some important things you need to know. Ask these questions of each potential hotel so you can accurately compare your options.

- Is there a minimum number of rooms required to reserve a block?
- What happens if we don't fill the room block? Will we be charged?
- What if we need to add more rooms?
- What is included in the room rate? (This could consist of things like continental breakfast, late checkout times, or a pool.)
- Will the block of rooms be close together?
- What is the room rate?
- Is there a cutoff date to reserve a room in the block?
- Should our guests make their reservations by phone or using online reservation codes?
- Will you deliver guest gifts to hotel rooms or hand them out at check in? Is there a fee for this?
- Does the hotel provide shuttle services for the airport or other locations in the area?
- Are there any perks for the couple?

TRANSPORTATION

Use this worksheet to plan and keep track of your wedding day transportation for the bridal party and guests.

TRANSPORTATION FOR THE WEDDING PARTY

Transportation Service: ..

Phone Number: ..

E-mail: ..

Website: ..

Type of Vehicle: ..

Number of Vehicles: ..

PICKUP LOCATION	PICKUP TIME

TRANSPORTATION FOR OUT-OF-TOWN GUESTS

Transportation Service: ..

Phone Number: ..

E-mail: ..

Website: ..

Type of Vehicle: ..

Number of Vehicles: ..

PICKUP LOCATION	PICKUP TIME

ACCOMMODATIONS

Use this worksheet to keep track of accommodations for yourself and your guests.

THE MARRIED COUPLE AFTER THE WEDDING

Hotel: ...

Address: ...

Phone Number: ...

E-mail: ...

Website: ...

Room Number: ...

Rate: ...

Check-In Day and Time: ...

Checkout Day and Time: ..

THE WEDDING PARTY

Hotel: ...

Address: ...

Phone Number: ...

E-mail: ...

Website: ...

Room Number: ...

Rate: ...

Check-In Day and Time: ...

Checkout Day and Time: ..

NAME	ROOM NUMBER	ARRIVE	DEPART

OUT-OF-TOWN GUESTS

Hotel 1: ..

Address: ..

Phone Number: ..

E-mail: ..

Website: ..

Number of Rooms: ..

Rate: ..

Check-In Day and Time: ..

Checkout Day and Time: ..

Hotel 2: ..

Address: ..

Phone Number: ..

E-mail: ..

Website: ..

Number of Rooms: ..

Rate: ..

Check-In Day and Time: ..

Checkout Day and Time: ..

Hotel 3: ..

Address: ..

Phone Number: ..

E-mail: ..

Website: ..

Number of Rooms: ..

Rate: ..

Check-In Day and Time: ..

Checkout Day and Time: ..

Hotel 4: ..

Address: ..

Phone Number: ..

E-mail: ..

Website: ..

Number of Rooms: ..

Rate: ..

Check-In Day and Time: ..

Checkout Day and Time: ..

Hotel 5: ..

Address: ..

Phone Number: ..

E-mail: ..

Website: ..

Number of Rooms: ..

Rate: ..

Check-In Day and Time: ..

Checkout Day and Time: ..

Hotel 6: ..

Address: ..

Phone Number: ..

E-mail: ..

Website: ..

Number of Rooms: ..

Rate: ..

Check-In Day and Time: ..

Checkout Day and Time: ..

ACTIVITIES FOR OUT-OF-TOWN GUESTS

Gather some helpful info for your out-of-town guests. Suggest your favorite activities, dining options, and interesting places to visit in the city where your wedding is taking place.

RESTAURANTS

..
..
..
..
..
..
..
..
..
..

LOCAL ATTRACTIONS

..
..
..
..
..
..
..
..
..
..

OUTDOOR ACTIVITIES

..
..
..
..
..
..
..
..

CHILDCARE SERVICES

..
..
..
..
..
..
..
..

ONE-MONTH-OUT CALENDAR

You're in the final stretch! Use this calendar and checklist to keep track of your final to-dos, tasks, and deadlines in the weeks leading up to the big day.

4 WEEKS OUT	NOTES
❏ Pick up items, like guest book, card box, and others	
❏ Obtain marriage license	
❏ Call anyone who hasn't RSVP'd	
❏ Order or print day-of stationery: place cards, menus, programs, table numbers, and others	

3 WEEKS OUT	NOTES
❏ Confirm room blocks and transportation services	
❏ Finalize song list for reception	
❏ Create seating chart, if applicable	

2 WEEKS OUT	NOTES
❏ Have final suit and dress fittings	
❏ Notify all vendors of final guest count	
❏ Complete and organize all DIY projects	
❏ Finalize shot list with photographer	
❏ Send wedding-day timeline to bridal party	
❏ Send wedding-day timeline to all vendors	

1 WEEK OUT	NOTES
☐ Confirm hair, makeup, and nail appointments	
☐ Get dress steamed and pick it up	
☐ Pack for honeymoon	
☐ Arrange for rental attire returns	
☐ Prepare wedding emergency kit	
☐ Pack wedding-day bag	

1 DAY BEFORE	NOTES
☐ Attend wedding rehearsal	
☐ Attend rehearsal dinner	
☐ Give out wedding party gifts	
☐ Prepare vendor thank-you cards, final payments, and tip envelopes	
☐ Get mani-pedi	

ACCOMMODATIONS, TRANSPORTATION, AND MORE

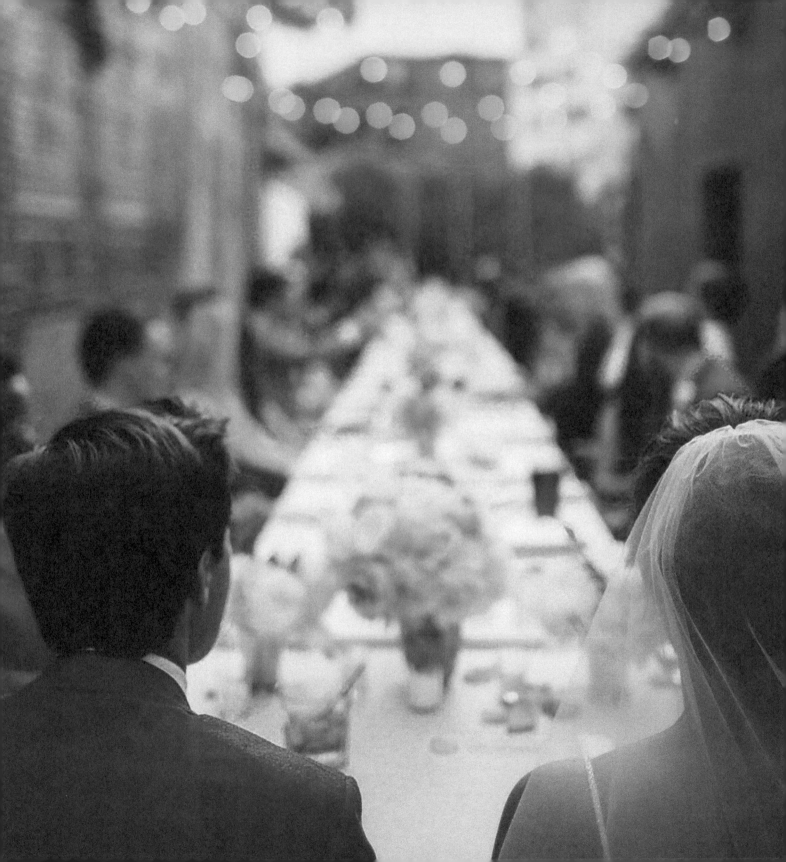

The Big Day

THE BIG DAY HAS finally arrived! After months of planning, you're going to walk down the aisle and exchange your vows with the love of your life. You've done the hard work and prepared as best you can, so let your talented vendor team and helpers do their jobs. On your wedding day, you'll want to be able to focus on being present and in the moment so you can truly enjoy your time with your loved ones.

SAVVY TIPS

1. DON'T FORGET TO EAT. Many couples find they forget to feed themselves on their wedding day. You obviously want to look great, but don't forget to eat breakfast. You'll need the energy to get through the long day, and being "hangry" won't help you keep your cool if things don't go perfectly as planned.

2. HAVE AN EMERGENCY KIT. Be sure to pack a wedding-day survival kit and fill it with items you may find yourself needing on the big day. It's helpful to have certain things within reach, like safety pins, scissors, and other such items.

3. PREPARE FOR THE DAY-OF. Make sure you give yourself plenty of time in the week before your wedding to do prep work to make the big day go more smoothly. Pack your wedding-day and wedding-night bags, organize any DIY projects and decor for transport, and get your timelines distributed to all necessary parties.

4. TAKE IT ALL IN AND ENJOY EVERY MOMENT. Make sure to pause and be aware of the present moment. Take a mental picture of your partner's face at the end of the aisle. Imprint the joy on your parents' faces into your memories. You'll remember these moments for the rest of your life.

5. BREATHE! LET LITTLE THINGS GO. Things will likely go wrong on your wedding day, but it's important to remain focused on what's truly important. When things get stressful, take a deep breath and remember that it's your wedding day! Let the small snags and snafus roll off your back. Choose to let things go, surrender to the joy of the day, and enjoy every moment.

REHEARSAL CHECKLIST

- ☐ Order of Ceremony
- ☐ Full Wedding-Day Timeline
- ☐ Checklists for Helpers
- ☐ Fake Bouquet (Ribbon Bouquet)
- ☐ Stickers or Tape
- ☐ Wedding Party Gifts

- ☐ Bride and Groom Gifts
- ☐ Music Player
- ☐ Sound System
- ☐ Guest Book and Pen

WEDDING REHEARSAL

The whole point of having a wedding rehearsal is to get the order, pace, flow, and spacing down for the main activities of the ceremony.

- ORDER OF PROCESSION: Practice the entrance of the wedding party into the ceremony space. Will the bridesmaids and groomsmen enter separately or as duos? Decide and practice the order.
- ESTABLISH THE PACE: Decide how quickly or slowly the bridal party should process down the aisle. The speed or pace may depend on the tempo of the music used for the processional.
- VISUAL SPACING: While rehearsing the processional, also keep the spacing of the attendants in mind. You may choose to allow each member to walk the entire aisle before the next person begins. Also mark the spots where each attendant should stand near the altar.
- READINGS AND RITUALS: Mark out times and positions for any major rituals or readings during the ceremony. The couple may have to move to a certain area to perform a unity candle ceremony, and the readers will practice moving to the area where they will be speaking.
- ORDER OF RECESSION: Practice the exit of the happy couple, followed by each member of the wedding party, the officiant, and the couple's parents.

ORDER OF CEREMONY

A wedding ceremony is made up of various possible components. Check out this rough outline, and cross out any items you don't plan to include:

- Prelude
- Seating of the Grandparents and Parents
- Processional
 - Attendants
 - Ring Bearer
 - Flower Girl
 - Bride
- Welcome
- Opening Prayer
- Reading 1
- Ritual
 - Unity Candle
 - Sand Ceremony
 - Handfasting
 - Other
- Reading 2
- Song or Music
- Declaration of Intention
- Exchange of Vows
- Blessing of Rings
- Exchange of Rings
- Marriage Blessing
- Declaration of Marriage
- First Kiss
- Presentation of the Couple
- Recessional
- Receiving Line

Tasks to Delegate

On the wedding day, you won't want to be running around doing things yourself, so you need to learn to delegate. Designate a point of contact who can field questions for both you and your partner. This dedicated person should be able to handle all queries in regard to setup, delivery, and logistics, consulting you only if absolutely necessary. Between your day-of coordinator (if you have one), your bridal party, and other wedding helpers, delegate the following tasks to make sure they get done:

- Dispensing the family flowers to members of your families.

- Picking up and delivering food to the bridal party while getting ready.

- Showing guests to their seats for the ceremony and directing them to the reception.

- Distributing vendor tips and payment envelopes.

- Setting up the guest book.

- Setting up the gift table.

CEREMONY CHECKLIST

Use this checklist to make sure you have all the items and accessories needed for your wedding ceremony.

CEREMONY PAPER AND SIGNAGE

☐ Programs
☐ Reception Map and Directions
☐ Signage
☐ Marriage License
☐ Engagement Photo

CEREMONY ACCESSORIES

☐ Guest Book Table
☐ Guest Book
☐ Music or Sound System

☐ Seating
☐ Unity Candle or Sand Ceremony Items (if using)
☐ Flower Girl Basket
☐ Ring Bearer Pillow

CEREMONY FLORALS AND DECOR

☐ Boutonnieres
☐ Bouquets
☐ Altar Decor
☐ Aisle Decor
☐ Miscellaneous Decor

THE VOWS

~~~~~~

Use this space to record your plans for your wedding vows. Do you plan to use a prewritten script you found somewhere? Are you each planning to write your own personal vows? Make a decision and write them here.

# RECEPTION SCHEDULE

The outline below provides timing suggestions for a four-hour reception. Use it to map out a timeline for your reception.

## Four-Hour Reception

00:00 – Cocktail Hour

01:00 – Guests Take Seats for Reception

01:10 – Newlyweds and Bridal
       Party Arrival

01:15 – First Dance

01:20 – Cheers and Toasts

01:30 – Dinner is Served

02:45 – Party and Dancing

03:00 – Cake Cutting

03:45 – Last Dance

04:00 – Couple Exit

# RECEPTION CHECKLIST

Use the following checklist to make sure you have everything you'll need for the reception.

- ☐ Tables and Chairs
- ☐ Decorations
- ☐ Linens or Napkins
- ☐ Centerpieces
- ☐ Flower Arrangements
- ☐ Music
- ☐ Sound System
- ☐ Dance Floor
- ☐ Wedding Favors
- ☐ Cake Topper
- ☐ Catering Items

- ☐ Liquor, Beer, Wine, or Nonalcoholic Beverages
- ☐ Dishes
- ☐ Silverware
- ☐ Glassware
- ☐ Toasting Flutes
- ☐ Cake Knife and Server
- ☐ Printable and Paper Items:
  - Menus
  - Table Numbers
  - Escort Cards or Place Cards
  - Signage

# TIPPING

While tipping at weddings has become more common as of late, it isn't mandatory or expected by most professionals, with the exception of service-based businesses. What can go further than a cash tip is writing positive reviews on various wedding sites and social media if you had a pleasant experience.

## TIPS FOR TIPPING

**CHECK YOUR CONTRACTS.** Some vendors include gratuity in their total price. Check all the line items so you don't double-tip.

**DON'T TIP BUSINESS OWNERS.** If the vendor is the primary business owner, don't feel obligated to tip him or her.

**THANK THOSE WHO GO ABOVE AND BEYOND.** If you have vendors who put forth extraordinary effort or go far beyond the call of duty to make your day special, be sure to give them a gratuity to show you appreciate it.

| ITEM | PROTOCOL | SUGGESTED TIP | TOTAL TIP AMOUNT |
|---|---|---|---|
| Catering | Expected | 15% to 20% of total bill | |
| Hair and Makeup | Expected | 15% to 25% of service | |
| DJ | Optional | 10% to 15% of service | |
| Transportation | Expected | 15% if not included in bill | |
| Florist | Optional | 10% to 15% if florist goes above and beyond | |
| Wedding Coordinator | Optional | 10% to 15% if coordinator goes above and beyond | |
| Photographer | Optional | $50 to $200 | |
| Venue Staff | Optional | $20 to $50 each if no service charge included in bill | |

| ITEM | PROTOCOL | SUGGESTED TIP | TOTAL TIP AMOUNT |
|------|----------|---------------|------------------|
| Officiant | Expected | $100 donation to church or to vendor | |
| Rental Delivery | Expected | $5 to $10 per delivery person | |

# SOCIAL MEDIA

If you're planning to document your day via social media, use the following page to record the details of your online coverage of your wedding day. Instead of including a hashtag on your invitations, put hashtag information on your wedding website.

## WEDDING WEBSITE

URL: ...................................

Login: ..................................

Password: ...............................

Wedding Hashtag: .........................

Bachelor Party Hashtag: ..................

Bachelorette Party Hashtag: ..............

Snapchat Filter: .........................

...................................

# YOUR WEDDING-DAY PACKING CHECKLIST

Consult this checklist to make sure you have everything you personally need for the big day. Try your best to prepare this collection of items in the week leading up to the wedding so you're not rushed at the last minute.

## ATTIRE

- ☐ Wedding Rings
- ☐ Wedding Dress
- ☐ Hair Accessories or Veil
- ☐ Dress Accessories or Sash
- ☐ Garter
- ☐ Wedding Jewelry
- ☐ Engagement Ring
- ☐ Shapewear
- ☐ Undergarments
- ☐ Bridal Purse or Clutch
- ☐ Wedding Suit
- ☐ Shirt
- ☐ Belt
- ☐ Cuff Links
- ☐ Tie
- ☐ Socks
- ☐ Wedding Shoes
- ☐ Wedding-Night Lingerie or Pajamas
- ☐ Day-After Clothes

## JUST IN CASE

- ☐ Wedding Emergency Kit
- ☐ Steamer for Wrinkles
- ☐ Makeup for Touch-Ups
- ☐ Toiletries for Wedding Night
- ☐ Cell Phone and Charger

## OTHER ESSENTIALS

- ☐ Contracts, Permits, and Insurance Documents, Wedding-Day Timeline
- ☐ Important Names and Numbers
- ☐ Photography Shot List

# WEDDING EMERGENCY KIT

Things tend to pop up on the wedding day, so it's important to have a stocked emergency kit in case of accidents, spills, or other minor mishaps. Feel free to pack these must-haves in your wedding-day survival kit.

- ☐ Water
- ☐ Breath Mints
- ☐ Vitamin C Packets
- ☐ Static Guard
- ☐ Mini Sewing Kit
- ☐ Safety Pins
- ☐ Stain Remover Wipes
- ☐ Tide to Go Pen
- ☐ Healthy Snacks
- ☐ Lavender Essential Oil
- ☐ Drinking Straws
- ☐ Lint Roller
- ☐ Antacid Tablets
- ☐ Hairspray

- ☐ Antibacterial Gel
- ☐ Body Lotion
- ☐ Pain Reliever
- ☐ Deodorant
- ☐ Tissues
- ☐ Bobby Pins
- ☐ Clear Nail Polish
- ☐ Band-Aids
- ☐ Lip Balm
- ☐ Pen and Paper
- ☐ Bug Spray
- ☐ Sunscreen
- ☐ Face Wipes or Blotting Papers
- ☐ Umbrellas

Congratulations! The day is finally here! Take a deep breath, make sure to eat and stay hydrated, and enjoy every moment!

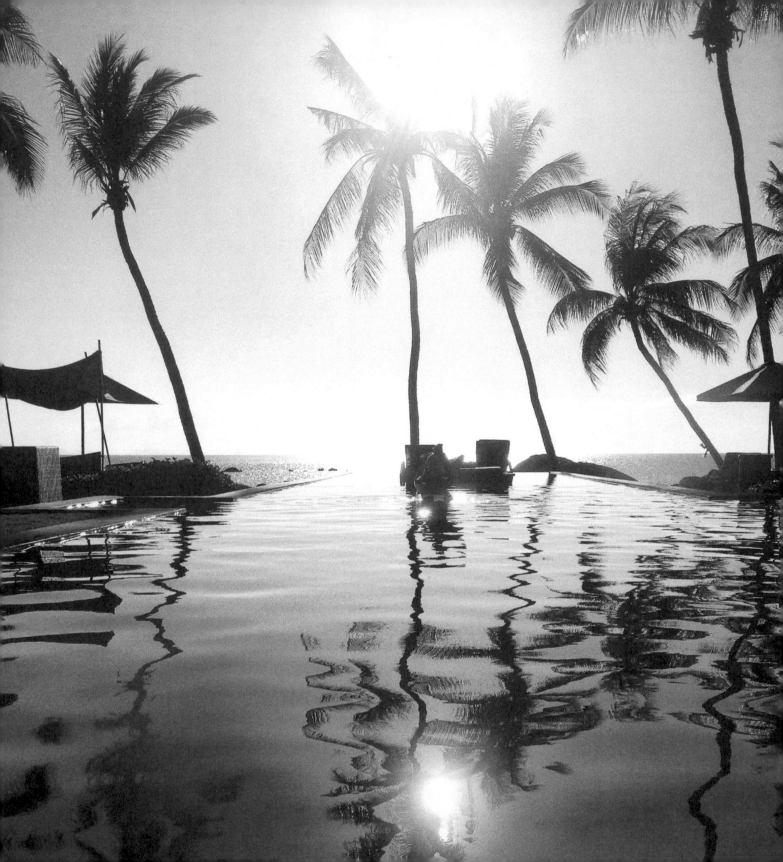

CHAPTER 13

# On to the Honeymoon

TRADITIONALLY, THE HAPPY COUPLE embarks on a celebratory trip in the days after the wedding, otherwise known as a honeymoon. These days it seems that the word is synonymous with luxury or extravagance, but you don't have to spend a small fortune to have an enjoyable honeymoon. Just like your wedding plans, your honeymoon can reflect your personal values and goals, and should be planned within your financial means.

Perhaps you chose to plan your wedding on a smaller budget because you want to take the trip of a lifetime for your honeymoon. Or maybe you are going low budget for both events because you're saving for a down payment on your first home together. If funds are extra tight, you may opt for a mini-moon in the days after the wedding and plan a larger trip for your one-year anniversary. Choose the option that works the best for your values and your budget!

# SAVVY TIPS

**1. SIGN UP FOR TRAVEL DEAL SITES.** If you want to get the best deals on anything from flights to hotel stays, sign up for e-mail updates from the major airlines and travel deal sites. Travelzoo, Expedia, and even Groupon have incredible deals on vacation packages.

**2. BE OPEN TO OPTIONS.** If you don't have a specific dream destination in mind, you can always follow where the best deal leads you. A two-week cruise through the Caribbean can be more affordable and enjoyable than a five-day trip to Hawaii with long-haul flights. Be prepared to jump when you find a good deal.

**3. TAKE ADVANTAGE OF CREDIT CARD REWARDS.** Sign up for a points-earning credit card and take advantage of rewards bonuses. Many of these cards offer points bonuses for meeting certain spending thresholds in the first few months of use. Using a card like this to pay for large wedding expenses, like catering, could end up earning you a huge mileage bonus for an airline, allowing you to book your honeymoon flights for free! Just make sure to pay off your balance each month.

**4. SET UP A HONEYMOON REGISTRY.** If you and your partner already cohabitate and have all the household necessities, consider setting up a honeymoon registry to fund the trip of your dreams. Use a site like Honeyfund.com to create a registry where your guests can gift money toward different experiences, travel, hotel stays, and more.

**5. PACK SMART.** Depending on the airline you fly, you may have to pay extra fees for checked or overweight baggage, so pack your bags carefully. To ensure savings, opt for carry-on-only luggage; just know you'll have to pack light. Consider putting together a capsule wardrobe with pieces you can mix and match in different ways to help you get through a longer trip with fewer items.

**6. USE FLIGHT COMPARISON SITES.** Use Google Flights to search flight options from various airlines for the dates you're interested in. This allows you to see the best prices available for your given timeframe. You can even subscribe to price updates on the flights or dates you prefer, so you can jump on a deal when the cost drops.

**7. BE FLEXIBLE WITH DATES.** If cost is a big factor when it comes to your honeymoon, try to be flexible on timing. You may find that it would be less stressful and less expensive to take off on a trip that occurs weeks or even months later than your wedding day. No matter when you take your honeymoon, you'll still get to cherish the experience of intentional time off to enjoy each other's company.

**8. BOOK A TRIP YOU'LL ENJOY.** Don't feel compelled to plan a trip that doesn't suit your tastes or personalities. If you're not the types to lounge by a pool all day sipping piña coladas, don't book that trip. If you're adventurous types, plan something with lots of activities and excursions. If you're happier hitting the ski slopes than you are lying on a beach, don't feel compelled to plan a tropical vacation. Your honeymoon should be about making memories with your new spouse, doing things you love to do together.

**9. CONSIDER A TRAVEL AGENT.** If you want a stress-free trip-planning experience led by a knowledgeable professional, consider working with a travel agency. A travel agent can save you money with packages that include airfare and hotel stays, and sometimes even rental cars, too. They also know the patterns of pricing and can help you choose the right place at the right time, so you get the best price on your dream trip!

**10. MENTION YOU'RE HONEYMOONING.** Whether booking restaurant reservations or hotel stays, you could score some extra perks, upgrades, or value-adds by mentioning that you are celebrating your honeymoon. Share your newlywed status with pride and watch the perks roll in.

## DISCUSSION QUESTIONS

1. What activities do we like to do, together and individually?

2. What sounds like more fun: beach, city, or mountains?

3. When we travel, what do we like to do: relax, explore, veg out, indulge, rough it, live like a local, or take guided tours?

4. How much money do we want to spend on our honeymoon?

# HONEYMOON INSPIRATION WORKSHEET

Daydreaming about honeymoon destinations can be one of the more fun parts of getting married. Use this worksheet to map out your ideas.

**Write in your top three dream honeymoon destinations.**

| PARTNER 1 | PARTNER 2 |
|---|---|
| 1. | 1. |
| 2. | 2. |
| 3. | 3. |

## HONEYMOON QUIZ

Want to find the perfect honeymoon destination to celebrate your union? Take the following quiz to identify your dream trip location.

**1. YOUR FRIENDS DESCRIBE YOU AS:**

a. Friendly

b. Adventurous

c. Glamorous

d. Laid-back

e. Bohemian

**2. WHAT'S IN YOUR SUITCASE?**

a. A country guidebook or itinerary

b. Hiking or scuba gear

c. Dressy clothes and heels

d. Bathing suits and sunscreen

e. Your journal

**3. FAVORITE SOUVENIR:**

a. A piece of jewelry from a local artisan

b. A rock or shell you picked up on an adventure

c. A fabulous pair of shoes

d. A golden suntan

e. Artisanal coffee beans from a local beanery

**4. YOUR FAVORITE SHOES ARE:**

a. Sensible flats

b. Tennis shoes

c. Sexy pumps

d. Flip-flops

e. Vegan sneakers

### 5. IDEAL DATE NIGHT:

   a. Romantic meal at a hot restaurant

   b. Something high-energy, like riding a Jet Ski

   c. Cocktails at a rooftop bar

   d. Candlelight dinner on the beach

   e. Seeing local theater or a comedy show

### 6. BEVERAGE OF CHOICE:

   a. A glass of wine

   b. Bottled water

   c. Vodka soda

   d. Margarita

   e. Kombucha

### 7. YOUR INSTAGRAM FEED CONSISTS MOSTLY OF:

   a. Travel photos and architecture

   b. The mountains you hike on the weekends

   c. City lights and rooftop views

   d. Beautiful beach sunsets

   e. Coffee and food photos

### 8. HONEYMOON BUCKET LIST ACTIVITY:

   a. Seeing the sights and visiting museums

   b. Scuba diving, hang gliding, or other adventures

   c. Shopping and fine dining

   d. Relaxing on the beach

   e. Snuggling up in bed with your partner reading books

### 9. TRAVEL MUST-HAVE:

   a. Translation app

   b. Fitness tracker

   c. Cell phone charger for all those selfies

   d. Sunglasses

   e. A fully stocked Kindle

### 10. FIRST THING YOU LOOK FOR WHEN YOU GET OFF THE PLANE:

   a. A list of local landmarks to visit

   b. The adventure or excursion desk

   c. The lobby bar for a glass of champagne

   d. The nearest beach

   e. A hammock to nap in

Mostly **A**s: Immerse Yourself in Culture. Consider destinations with a rich history, such as Rome or Paris.

Mostly **B**s: Adventure-Moon. Choose a trip that offers plenty of excursion and adventure options, such as Costa Rica, the Dominican Republic, or the Rocky Mountains.

Mostly **C**s: Bright Lights, Big City. Pick a metropolitan city that gives you various options for food, nightlife, shopping, and entertainment.

Mostly **D**s: Beachy and Relaxing. Vacation to you is all about downtime and sunshine. Choose a beach destination and get your tan on.

Mostly **E**s: Laid-Back Homebody. Consider choosing a location where you can live like a local. Stay in an Airbnb and leisurely enjoy your time in a new city.

## BOOKING YOUR HONEYMOON

- [ ] Set your honeymoon budget
- [ ] Get a rewards credit card
- [ ] Research possible locations
- [ ] Set up honeymoon registry
- [ ] Sign up for hotel and airline deal alerts
- [ ] Buy your plane tickets
- [ ] Book your hotel or resort
- [ ] Ask hotel about specials for honeymooners
- [ ] Schedule transportation or use airport transfers

- [ ] Get or renew your passport
- [ ] Apply for necessary visas
- [ ] Purchase travel insurance
- [ ] Research and plan activities
- [ ] Confirm every detail
- [ ] Make copies of all travel documents and itineraries
- [ ] Check the weather
- [ ] Pack your bags
- [ ] Jet off and enjoy your honeymoon!

## POST-WEDDING TO-DOS

- [ ] Return rented attire
- [ ] Return rental equipment
- [ ] Take wedding dress to be cleaned
- [ ] Make sure all vendor bills have been paid in full
- [ ] Go on your honeymoon
- [ ] Record gifts and givers for thank-you notes
- [ ] Write and mail thank-you notes

- [ ] Write wedding vendor reviews online
- [ ] Name change (if applicable)
- [ ] Review wedding photos and order prints
- [ ] Purchase life insurance
- [ ] Have wills drafted or updated
- [ ] Meet with a financial planner
- [ ] Send out new contact info or change of address (if necessary)

# CONTRACT & NEGOTIATION TIPS

When meeting with possible vendors, it's important to be armed with knowledge of typical contracts and agreements so you know if something is amiss. Arriving well informed will also allow you to have a better starting point for potential negotiations. Keep these things in mind when considering contracts and negotiating terms or prices with your vendors.

## SAVVY TIPS

**1. KNOW YOUR BUDGET.** As explained in The Vision, setting your budget before meeting with vendors is so crucial. You'll want to know if a vendor's pricing is even in the realm of possibility before meeting with one.

**2. BE REALISTIC.** There's always room for negotiation but not if your budget is far below a vendor's starting rates. Show respect by not wasting the time of vendors who are obviously out of your price range.

**3. ASSOCIATES, ASSISTANTS, AND APPRENTICES.** If you fall in love with a vendor's work but can't afford the prices, inquire about his or her assistants, associates, or apprentices. You might just book an up-and-coming talent for considerably less cost than the main business owner would charge.

**4. LESS COVERAGE, LESS COST.** Some vendors have prices that can be structured at an hourly rate, so you may be able to get fewer hours of coverage for a lower cost than one of their standard packages.

**5. FREEBIES AND PERKS.** Ask your vendors about referral bonuses, discounts, credits, or perks. When it comes to the vendors you are spending the most on, you may be able to get them to throw in some freebies if you ask nicely.

**6. COME IN WITH COMPARISONS.** If you plan to interview multiple vendors for the same position (which you should), come into your meeting armed with quotes from their competitors. You may be able to play them off each other to get the best price.

**7. GIVE A MAX BID.** Instead of asking vendors to lower their price on a standard package, ask what they could offer you within your given budget. Tell them the maximum you're able to spend on this service and see what they can do within your price range.

**8. COMPROMISE IS KEY.** Realize that negotiation means there will need to be compromises on both sides of the table. You may have to accept fewer hours of coverage or appetizer options in order to meet the cost you're planning to spend.

**9. VENDOR REFERRALS.** Ask your other vendors if they are able to secure any discounts for you with other wedding companies. Vendors who refer business to each other are sometimes able to get you a special discount.

**10. BE KIND.** This should be a no-brainer, but it bears mentioning. Have you ever heard the phrase, "You can catch more bees with honey"? If you're a nice person, the vendors in question may be more likely to negotiate with you.

## CONTRACT NOTES

**1. READ AND REREAD.** Read each page of a contract thoroughly to make sure all the bases are covered. Take time to mark up the document with any errors or areas that are unclear.

**2. GET AN EXTRA SET OF EYES.** Ask your parents, your wedding coordinator, your partner, or even a lawyer you are friendly with to look over your contracts with you. They just might catch something you didn't!

**3. DOUBLE-CHECK ALL DETAILS.** Carefully review all the details outlined in the contract, such as service hours, cost, and payment schedules. Also, be sure to confirm dates, delivery times, and other logistics.

**4. NOTE THE FINE PRINT.** Check your contract for any reference to additional fees that could be incurred, details on what would happen if the vendor fails to complete their services, and any emergency clauses.

**5. GET CLARIFICATION AND MAKE UPDATES.** After you've made note of any errors and identified points that you have questions about, meet with or call the vendor to get clarification. Then have him or her update the contract with corrections and updated descriptions.

**6. SIGN AND GET COPIES.** Request dual-signed copies of your contracts and keep them for easy reference. Make a digital copy just in case you need to access them on the go.

# IMPORTANT NAMES & NUMBERS

### WEDDING COORDINATOR

Name: .................................................. Website: ..................................................

Address: .............................................. E-mail: ..................................................

.......................................................... Phone: ..................................................

### CATERING MANAGER

Name: .................................................. Website: ..................................................

Address: .............................................. E-mail: ..................................................

.......................................................... Phone: ..................................................

### CEREMONY VENUE MANAGER

Name: .................................................. Website: ..................................................

Address: .............................................. E-mail: ..................................................

.......................................................... Phone: ..................................................

### RECEPTION VENUE MANAGER

Name: .................................................. Website: ..................................................

Address: .............................................. E-mail: ..................................................

.......................................................... Phone: ..................................................

## OFFICIANT

Name: ..................................................

Address: ..................................................

..................................................

Website: ..................................................

E-mail: ..................................................

Phone: ..................................................

## DRESS SHOP

Name: ..................................................

Address: ..................................................

..................................................

Website: ..................................................

E-mail: ..................................................

Phone: ..................................................

## DRESS ALTERATIONS CONTACT

Name: ..................................................

Address: ..................................................

..................................................

Website: ..................................................

E-mail: ..................................................

Phone: ..................................................

## TAILOR

Name: ..................................................

Address: ..................................................

..................................................

Website: ..................................................

E-mail: ..................................................

Phone: ..................................................

## PHOTOGRAPHER

Name: ..................................................

Address: ..................................................

..................................................

Website: ..................................................

E-mail: ..................................................

Phone: ..................................................

## VIDEOGRAPHER

Name: ..................................................

Address: ..................................................

..................................................

Website: ..................................................

E-mail: ..................................................

Phone: ..................................................

IMPORTANT NAMES & NUMBERS

## RENTAL COMPANY CONTACT

Name: .................................................

Address: .................................................

.................................................

Website: .................................................

E-mail: .................................................

Phone: .................................................

## REHEARSAL DINNER VENUE MANAGER

Name: .................................................

Address: .................................................

.................................................

Website: .................................................

E-mail: .................................................

Phone: .................................................

## TRANSPORTATION CONTACT

Name: .................................................

Address: .................................................

.................................................

Website: .................................................

E-mail: .................................................

Phone: .................................................

## FLORIST

Name: .................................................

Address: .................................................

.................................................

Website: .................................................

E-mail: .................................................

Phone: .................................................

## DJ

Name: .................................................

Address: .................................................

.................................................

Website: .................................................

E-mail: .................................................

Phone: .................................................

## BAKER

Name: .................................................

Address: .................................................

.................................................

Website: .................................................

E-mail: .................................................

Phone: .................................................

## LIQUOR SUPPLIER / BARTENDER

Name: .................................................

Address: ...............................................

.................................................

Website: ................................................

E-mail: .................................................

Phone: .................................................

## NOTES

# RESOURCES

### Books

*The Broke-Ass Bride's Wedding Guide*
    by Dana LaRue
*The Knot Ultimate Wedding Planner*
    by Carley Roney
*Loverly Wedding Planner* by Kellee Khalil
*A Practical Wedding* by Meg Keene

### Wedding Blogs and Planning Websites

Aisle Society, AisleSociety.com
The Broke-Ass Bride,
    TheBrokeAssBride.com
The Budget Savvy Bride,
    TheBudgetSavvyBride.com
Emmaline Bride, EmmalineBride.com
Intimate Weddings,
    IntimateWeddings.com
Something Turquoise,
    SomethingTurquoise.com
Snippet & Ink, SnippetAndInk.com

### Bridesmaids Attire

Azazie, Azazie.com
David's Bridal, DavidsBridal.com
ModCloth, ModCloth.com
Rent the Runway, RentTheRunway.com
Vow To Be Chic, VowToBeChic.com
Weddington Way, WeddingtonWay.com

### Deals and Coupons

Ebates, Ebates.com
Groupon, Groupon.com
RetailMeNot, RetailMeNot.com

### Decor

DIY Uplighting, DIYuplighting.com
Etsy, Etsy.com
Event Decor Direct,
    EventDecorDirect.com
Luna Bazaar, LunaBazaar.com
Michaels, Michaels.com
Oriental Trading Company,
    OrientalTrading.com
Rent My Wedding, RentMyWedding.com

### Destination Weddings

Destination Weddings,
  DestinationWeddings.com

### DIY Tools and Tutorials

Canva, Canva.com

Craftsy, Craftsy.com

Creative Market, CreativeMarket.com

### Bridal Gowns

Azazie, Azazie.com

BHLDN, BHLDN.com

David's Bridal, DavidsBridal.com

### Favors

Beau-coup, Beau-coup.com

Oriental Trading Company, OrientalTrading.com

My Wedding Favors, MyWeddingFavors.com

### Flowers

BloomsByTheBox.com, BloomsByTheBox.com

FiftyFlowers, FiftyFlowers.com

### Groom and Groomsmen Attire

Bonobos, Bonobos.com

Menguin, Menguin.com

The Black Tux, TheBlackTux.com

The Tie Bar, TheTieBar.com

### Honeymoons

Airbnb, Airbnb.com

Expedia, Expedia.com

Google Flights, Google.com/flights

Groupon Getaways, Groupon.com/getaways

HomeAway, HomeAway.com

Honeyfund, Honeyfund.com

TripAdvisor, TripAdvisor.com

### Invitations

Basic Invite, BasicInvite.com

Download & Print, DownloadAndPrint.com

Paperless Post, PaperlessPost.com

Shutterfly, Shutterfly.com

Vistaprint, Vistaprint.com

Zazzle, Zazzle.com

### Money

Invibed, Invibed.com

Mint, Mint.com

Rize, RizeMoney.com

### Registry

Amazon, Amazon.com

Honeyfund, Honeyfund.com

Target, Target.com

### Software and Apps

Dropbox, Dropbox.com

Evernote, Evernote.com

Google Docs, docs.Google.com

Postable, Postable.com

### Wedding Website Builders

Appy Couple, AppyCouple.com

Minted, Minted.com

Zola, Zola.com

# INDEX

## A

Accessories. *See also* Rings
  ways to save, 87
  worksheet, 86
Accommodations
  for the couple, 156
  family and out-of-town
    guests, 157
  must-ask questions, 157
  overview, 155
  tips, 156
  wedding party, 156
  worksheet, 159–160
Addresses, 66
Alcohol, 120
Attire
  bridal party, 99
  bride, 75–82
  groom, 83–85

## B

Bachelor and bachelorette
  parties, 150
Bakers. *See* Cakes

Beauty plans
  final plan worksheet, 91
  ways to save, 90
  worksheet, 88–89
Best man, 100
The big day. *See* Wedding day
Bridal party
  attire worksheet, 99
  bridal party asks
    worksheet, 100
  choosing your bridal party
    worksheet, 97
  proposal options, 98
  ways to save, 101
Bridal showers, 150–151
Bridesmaids, 100
Budget. *See also* Ways to save
  average, 24
  couple contributions
    worksheet, 21–22
  50/20/30 rule, 19
  monthly budget, 19–20
  monthly savings plan, 20
  overview, 17
  real-life examples, 25–29

rings, 91
savings, 18–19
sticking to, 20
tips, 18
ways to save, 33
wedding budget breakdown
  worksheet, 30–32
wedding dresses, 74, 79
wedding fund worksheet, 23
wedding party, 96

## C

Cakes
  choosing the cake
    worksheet, 125
  comparing sweets
    worksheet, 123
  must-ask questions, 122
  overview, 122
  ways to save, 124
Calligraphy, 68
Catering
  choosing a caterer
    worksheet, 119

Catering *(continued)*
    comparing options
        worksheet, 118
    discussion questions, 115
    menu worksheet, 121
    must-ask questions, 117
    overview, 115
    stocking the bar worksheet, 120
    and venues, 54
    ways to save, 116
Ceremonies. *See also* Wedding day
    dream ceremony worksheet, 50
    event design and setup
        worksheet, 130
    music worksheet, 112
    rentals worksheets, 133–135, 137
CIY (cater it yourself), 116
Contracts, 48, 104, 185–186

**D**

Day-after brunches, 152
Decor
    discussion questions, 128
    DIY, 129
    event design and setup
        worksheet, 130
    inspiration worksheet, 131–132
    miscellaneous details, 136
    overview, 127
    rentals, 133–137
    tips, 128
    ways to save, 136
Desserts, 122–125
Destination weddings, 15
Discussion questions
    catering, 115
    decor, 128

guest list, 36
honeymoons, 179
invites, 64
vendors, 104
venues, 48–49
vision, 2
wedding party, 96
DIY
    accessories, 87
    decor, 129
    DJ, 113–114
    flowers, 140–142
    invites, 69
DJs, 7, 113–114
Dual-purpose venues, 49, 56

**E**

Engagement parties, 149
Entertainment, 53. *See also*
    Receptions
E-vites, 64

**F**

Family contributions, 18
Favors
    choosing your favors
        worksheet, 144
    overview, 138
    ways to save, 145
50/20/30 rule, 19
Finances. *See* Budget
Flowcharts, guest list, 36
Flowers
    DIY, 141–142
    inspiration worksheet, 139

making flower selections
    worksheet, 143
must-ask questions, 138
overview, 138
in-season, 142
ways to save, 7, 140
Food and drink. *See* catering
Full-service venues, 57

**G**

Gifts, wedding party, 96
Google Sheets, 66
Groom's attire. *See* Suits
Groomsmen, 100
Guest lists
    discussion questions, 36
    final list worksheet, 43–45
    flowchart, 36
    overview, 35
    potential list worksheet, 39–42
    tips, 36
    ways to save, 38

**H**

Hair
    beauty plan worksheet, 88–89
    final beauty plan worksheet, 91
    ways to save, 90
Honeymoons
    booking, 182
    discussion questions, 179
    inspiration worksheet, 180–181
    overview, 177
    tips, 178–179
Hotels, 156–160

**I**

Invites
    collecting addresses, 66
    discussion questions, 64
    to DIY or not to DIY
        worksheet, 69
    must-have details, 70
    overview, 63
    paper goods inspiration
        worksheet, 67
    save-the-dates, 64, 66, 70
    tips, 64
    ways to save, 68
    wedding websites, 64–65
    wording examples, 71

**L**

Logistics, venue, 48, 52

**M**

Maid of honor, 100
Makeup
    beauty plan
        worksheet, 88–89
    final beauty plan
        worksheet, 91
    ways to save, 90
Motifs and symbols, 67
Music. *See also* Receptions
    building your playlist
        worksheet, 114
    ceremony music worksheet, 112
    must-ask questions, 111
    overview, 111
    reception, 113
    and venues, 53

**N**

Nails
    beauty plan worksheet, 88–89
    final beauty plan worksheet, 91
Negotiation tips, 185–186

**O**

Officiants
    selecting, 59–60
    what to discuss, 61
Out-of-town guests. *See also*
    Accommodations;
    Transportation
    activities for worksheet, 161

**P**

Paper goods, 66, 67. *See also* Invites
Parties. *See also* Receptions
    bachelor and bachelorette, 150
    bridal showers, 150–151
    day-after brunch, 152
    engagement, 149
    overview, 147
    rehearsal dinner, 151
    tips, 148
    ways to save, 153
Photographers
    comparing photographers
        worksheet, 106
    creating a shot list
        worksheet, 110
    must-ask questions, 107
    overview, 105
    selecting a photographer
        worksheet, 109
    ways to save, 108

Postable.com, 66
Postcards, 68
Post-wedding to-dos, 182
Potlucks, 116
Pre-wedding events. *See* Parties
Priorities
    and budget, 24
    guest list, 36
    vision and, 2
    worksheet, 4–6

**R**

Receptions
    checklist, 170
    dream reception
        worksheet, 51
    event design and setup
        worksheet, 130
    rentals worksheets, 133–135, 137
    schedule, 170
Registries, 148
Rehearsal dinners, 151
Rehearsals
    checklist, 166
    order of ceremony, 167
Rentals
    accessories, 87
    bridal party attire, 101
    event, 133–137
    suits, 85
    wedding dresses, 81
Rings
    comparing rings worksheet, 92
    overview, 91
    tips, 91
    ways to save, 93
    the winners worksheet, 93

**S**

Sample sales, 81

Save-the-dates, 64, 66, 70

Saving money. *See* Ways to save

Shoes, 74, 101

Social media, 172

Suits

    inspiration worksheet, 83–84

    renting vs. buying, 85

    the suit worksheet, 85

    ways to save, 81

**T**

Timelines

    one-month-out calendar, 162–163

    one-year worksheet, 9–11

    six-month worksheet, 12–14

Tipping, 171–172

Tips

    accommodations, 156

    budget, 18

    contracts and

        negotiation, 185–186

    decor, 128

    guest list, 36

    honeymoons, 178–179

    invites, 64

    parties, 148

    rings, 91

    for tipping, 171–172

    vendors, 104

    venues, 48

    vision, 2

    wedding day, 166

    wedding-day look, 74

    wedding party, 96

Transportation

    overview, 155

    worksheet, 158

Travel

    destination weddings, 15

    honeymoons, 177–182

Tuxedos. *See* Suits

**V**

Values, 2

Vendors

    best order to book, 105

    cakes, 122–125

    catering, 115–121

    discussion questions, 104

    music, 111–114

    overview, 103

    photographers, 105–110

    tips, 104

    videographers, 107

Venues

    booking, 57

    comparing venues worksheet, 55

    destination weddings, 15

    discussion questions, 48–49

    dream ceremony worksheet, 50

    dream reception worksheet, 51

    dual-purpose, 49, 56

    event rentals, 133–137

    full-service, 57

    must-ask questions, 52–54

    our wedding venue worksheet, 58

    overview, 47

    selecting an officiant, 59–60

    tips, 48

    ways to save, 7, 56–57

Videographers, 107

Vision

    discussion questions, 2

    one-year timeline

        worksheet, 9–11

    overview, 1

    perfect celebration

        worksheet, 8

    priorities worksheet, 4–6

    six-month timeline

        worksheet, 12–14

    tips, 2

    ways to save, 7

    worksheet, 3

Vows, 169

**W**

Ways to save

    accessories, 87

    budget, 33

    cakes, 124

    catering, 116

    decor, 136

    favors, 145

    flowers, 140

    guest list, 38

    hair and makeup, 90

    invites, 68

    parties, 153

    photographers, 108

    rings, 93

    suits, 81

    venues, 56–57

    vision, 7

    wedding dresses, 81

    wedding party, 101

Wedding day. *See also* Receptions;
    Rehearsals
    ceremony checklist, 168
    emergency kit, 174
    one-month-out calendar, 162–163
    order of ceremony, 167
    overview, 165
    packing checklist, 173
    post-wedding to-dos, 182
    social media, 172
    tasks to delegate, 168
    tipping, 171–172
    tips, 166
    vows worksheet, 169
Wedding-day look
    accessories, 86–87
    dresses, 75–82
    hair and makeup, 88–91
    overview, 73
    rings, 91–93
    suits, 83–85
    tips, 74
Wedding dresses
    to-do list, 82
    dress types worksheet, 79
    the dress worksheet, 82
    inspiration worksheet, 76–77
    keeping track of the candidates
        worksheet, 80
    must-ask questions, 75
    tips, 74
    ways to save, 81
    what I like worksheet, 78
Wedding party
    bridal party asks worksheet, 100
    bridal party attire
        worksheet, 100
    choosing your bridal party
        worksheet, 97

discussion questions, 96
overview, 95
proposal options, 98
tips, 96
ways to save, 101
Wedding websites
    dos and don'ts, 65
    overview, 64
    and social media, 172
    what to include, 65
Worksheets
    accessorize your look, 86
    accommodations, 159–160
    activities for out-of-town
        guests, 161
    beauty plan, 88–89
    bridal party asks, 100
    bridal party attire, 99
    building your playlist, 114
    ceremony music, 112
    choosing a caterer, 119
    choosing the cake, 125
    choosing your bridal party, 97
    choosing your favors, 144
    comparing catering options, 118
    comparing photographers, 106
    comparing rental
        companies, 134–135
    comparing rings, 92
    comparing sweets, 123
    comparing venues, 55
    couple contributions, 21–22
    creating a shot list, 110
    decor inspiration, 131–132
    to DIY or not to DIY, 69
    dream ceremony, 50
    dream reception, 51
    the dress, 82

dress inspiration, 76–77
dress types, 79
event design and setup, 130
final beauty plan, 91
final guest list, 43–45
final rental selections and
    details, 137
flower inspiration, 139
honeymoon inspiration, 180–181
important names and
    numbers, 187–190
keeping track of the candidates
    (dresses), 80
making flower selections, 143
menu, 121
one-month-out calendar, 162–163
one-year timeline, 9–11
our weeding venue, 58
paper goods inspiration, 67
perfect celebration, 8
potential guest list, 39–42
priorities, 4–6
rentals, 133
selecting an officiant, 59–60
selecting a photographer, 109
six-month timeline, 12–14
stocking the bar, 120
the suit, 85
suit inspiration, 83–84
transportation, 158
vision, 3
vows, 169
wedding budget
    breakdown, 30–32
wedding fund, 23
what I like (dresses), 78
the winners (rings), 93

# ABOUT THE AUTHOR

JESSICA BISHOP is the founder of TheBudgetSavvyBride.com, the No. 1 online resource to help couples all across the world plan a beautiful wedding they can actually afford. She launched the site in 2008 while planning her own wedding, in response to finding a lack of resources and information for couples who are working with a small budget. Jessica has been nationally recognized as an expert on budget weddings and has shared her money-saving tips and tricks with outlets such as *Brides*, NBC, *Glamour*, *Cosmopolitan*, *Huffington Post*, Refinery29, and more.